Photography for Artists and Craftsmen

Claus-Peter Schmid

VNR **VAN NOSTRAND REINHOLD COMPANY**
NEW YORK CINCINNATI TORONTO LONDON MELBOURNE

To Bonny Kate

Van Nostrand Reinhold Company Regional Offices:
New York Cincinnati Chicago Millbrae Dallas
Van Nostrand Reinhold Company International Offices:
London Toronto Melbourne

Designed by Loudan Enterprises

Published by Van Nostrand Reinhold Company
A Division of Litton Educational Publishing, Inc.
450 West 33rd Street, New York, N.Y. 10001

16 15 14 13 12 11 10 9 8 7 6 5 4 3 2 1

Library of Congress Cataloging in Publication Data
Schmid, Claus Peter.
 Photography for artists and craftsmen.
 1. Photography of art. I. Title.
TR657.S35 778.9'9'7 74-17545
ISBN 0-442-27393-2

Inside covers, front and back show details from *Space Continuum,* a tapestry
by Lia Cook, U.S.A.

Acknowledgments

I would like to thank all the artists represented in this book for allowing me to demonstrate the different photographic techniques with their outstanding work. I am particularly indebted to the following galleries for granting permission to photograph objects on exhibition: Centre International de la Tapisserie Ancienne et Moderne, Lausanne, Switzerland; Ceramic Studio Schaffer-Schwaemmle, Munich, Germany; Gallery Cardillac, Munich, Germany; Gallery Handwerk, Munich, Germany; Gallery Rutzmoser, Munich, Germany; and Glashuette Erwin Eisch, Frauenau, Germany.

I would especially like to thank my wife, Bonny Kate Schmid-Burleson, for her enthusiastic support and advice. Her experience as an artist and writer played a vital part in creating this book.

Photographs and drawings are by the author unless credited otherwise.

Contents

Introduction

Recent years have seen a surging interest and involvement in the wide areas of handcraft and art. The individual artist faces an ever-growing demand for high-quality photographs — for art juries, customers, book and magazine editors, as well as for personal portfolios. Often a convincing photograph opens the door to wider recognition as an artist or craftsman. At the same time, photographs of art objects are extremely important as teaching aids, both to archive and to demonstrate craft techniques.

While the vital role of photography in the art world is undeniable, the instruction manuals available to the interested amateur provide little theoretical or practical information about the specific problems encountered in photographing art objects. This gap prompted me to write a book for artists and craftsmen who do know how to operate a camera on an amateur level but who lack the necessary knowledge and confidence to produce satisfactory photographs of their own work.

Taking good photographs of art objects need not be difficult; it is simply different from taking ordinary snapshots and thus requires an adaptation of general photographic principles to the specialized field of object photography. In the opening chapters, these basic principles are considered from the point of view of the object photographer in order to clear the way for advice on lighting, placing of objects, background selection, and specific problems. The intention of this book is to stress a practical approach to the problems of object photography and to find simple solutions that can be applied by the amateur without investing in an extensive photographic system. The photographs were taken by the author with equipment comparable to that owned by most amateurs: a standard 35-mm, single-lens reflex camera (Mamiya1000 DTL) and a 2 1/4-inch by 2 1/4-inch twin-lens camera (Mamiya 330). Lighting was provided by natural light and 500-watt bulbs in simple reflector bowls.

Finally, I have written this book with the conviction that the artist or craftsman, having obtained the necessary information, is ideally suited to photograph his or her work. The uniqueness of an art object is best understood by its maker, who is able to approach it with the sensitivity required to create a truly excellent object photograph.

1

Basic Photographic Concepts

Most amateur photographers are already familiar with the basic concepts of exposure time, f-stop, and depth of field. Their application to object photography, however, differs somewhat from ordinary snapshot conditions. While a snapshot usually requires a fast exposure time and a wide lens opening, a picture of an object is most likely to be taken on a tripod with a slow exposure speed and a small lens opening. These concepts are important and interrelated factors in controlling the quality of any photograph and must be adapted to the object situation in order to provide a sound framework for the specific problems discussed in the following chapters.

EXPOSURE TIME

The time during which the lens of a camera is opened is known as the *exposure time*. While the lens is open, light is acting on the film; in other words, the film is exposed to light. By varying the exposure time, the photographer is able to control the amount of light exposing the film.

Adjustable cameras offer exposure times from 1 second to 1/500, 1/1000, or even 1/2000 of a second. The exposure times are not designated by full fractions but by the denominators only, resulting in the following sequence, which is found on the exposure dials of most modern cameras:

 B 1 2 4 8 15 30 60 125 250 500 (1000 2000)

Exposure time decreases as the numbers increase; 4 signifies 1/4 of a second, for example; 8, 1/8 of a second. The logic behind these figures is that each consecutive exposure time opens the lens only half as long as the previous one. An exposure of 8 is only half as long and admits only half as much light as an exposure of 4.

The exposure-time sequence is usually headed by the letter B, which represents exposures longer than 1 second. When the exposure dial is set at B, the shutter will remain open and admit light for as long as the shutter-release button is pushed down, usually with the aid of a cable release (see Chapter 2). Long exposure times are possible only if the camera is mounted on a tripod.

7

F-STOP

The exposure time is one of two equally important factors in exposing a negative. The other is the lens opening, also called the lens aperture or, for short, the *f-stop*. The f-stop controls the amount of light passing through the lens by varying the size of the lens opening. This is done with a set of very fine metal blades, which constitute the lens diaphragm.

The size of the lens opening is indicated in f-numbers or f-stops. They are engraved on the aperture ring, which is incorporated into the lens body. On a 35-mm camera with a standard 50-mm or 55-mm lens, the full f-stops are:

f-16 f-11 f-8 f-5.6 f-4 f-2.8 f-2 f-1.4

F-16 designates the smallest opening; f-1.4, the widest. Some aperture rings have clicks for half-stops between the full f-stops. If yours doesn't, simply set the aperture ring so that the control mark for the f-stop points between two full f-numbers. Lenses with different focal lengths and large-format cameras have additional f-stops ranging from f-22 to f-90.

The size of the lens opening increases as the f-numbers decrease. The relationship is exactly the reverse of the exposure-time sequence: each consecutive f-stop doubles the quantity of light passing through the lens. The lens opening is twice as large and admits twice as much light at f-11 as at f-16; at f-8, four times as much light is acting on the film as at f-16.

It is obvious at this point that exposure time and f-stop are not only interrelated exposure factors, but they also have analogous calibrations: each consecutive stop doubles the amount of light acting on the film or vice versa. Given a certain light intensity, you set the lens diaphragm at f-8, for example, and determine that the necessary exposure time is 1/30 second. Under the same conditions, you could also set the f-stop at f-16 and the exposure time at 1/8 second or at 1/250 second if your f-stop is f-2.8; all three exposures would expose the film to an equal amount of light (see figure 1-1).

The variety of f-stop/exposure time combinations providing equal exposure does not mean that you will obtain identical results from whatever combination you may select. There is a fundamental difference between, say, f-16 at 1/8 second and f-2.8 at 1/250 second in the overall sharpness of the object recorded on the film. This difference is based on the third photographic concept — the one most important to the object photographer — depth of field.

1-1. Relationship between f-stop and exposure time. The lens opening (f-stop) increases in the same proportion as the exposure time decreases; the amount of light acting on the film remains the same at all the f-stop/exposure time combinations along the indicated line.

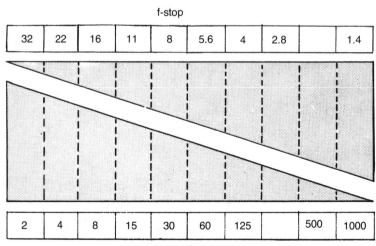

f-stop

| 32 | 22 | 16 | 11 | 8 | 5.6 | 4 | 2.8 | | 1.4 |

| 2 | 4 | 8 | 15 | 30 | 60 | 125 | | 500 | 1000 |

exposure time

DEPTH OF FIELD

Depth of field may be defined as the sharpness range between the nearest and farthest points that still appear sharp in a photograph (see figure 1-2). This range is always parallel to the back of the camera, and it extends in front of and behind the focusing plane, which explains why more than just the area that appears sharp during focusing is recorded as sharp in the final photograph. The depth-of-field preview button on most single-lens reflex cameras (see Chapter 2) allows you to determine roughly how much will appear sharp in the final photograph. Depth of field depends on three factors: the f-stop, the focal length of the particular lens, and the distance between camera and object.

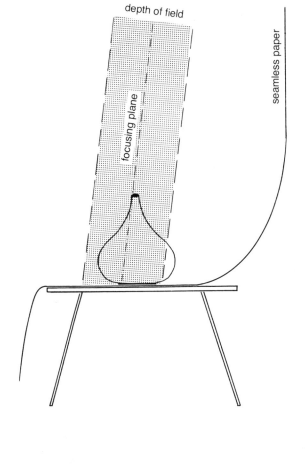

1-2. Position of depth of field when focusing on the neck of a vase.

F-stop

The f-stop concerns the object photographer most, since there is an active choice between several f-stops. The smaller the lens opening (higher f-numbers!), the greater the depth of field (see figure 1-3a). As overall sharpness of the subject is of prime importance in object photography, I recommend using the smallest or the next smallest f-stop (f-16 or f-11 on 35-mm cameras with 55-mm lens). Figures 1-4a and 1-5a show the same object photographed with a large and a small f-stop. The depth of field resulting from each of these f-stops is shown in figures 1-4b and 1-5b.

a. f-16

 f-8

 f-2.8

b. 35mm

 55mm

 135mm

c. 10 feet

 5 feet

 2½ feet

1-3. Factors influencing depth of field. (a.) Relative depth of field with a 55-mm lens at 10 feet when the f-stop is varied. (b.) Relative depth of field at f-8 at 10 feet when the focal length is varied. (c.) Relative depth of field at f-8 with a 55-mm lens when the distance is varied.

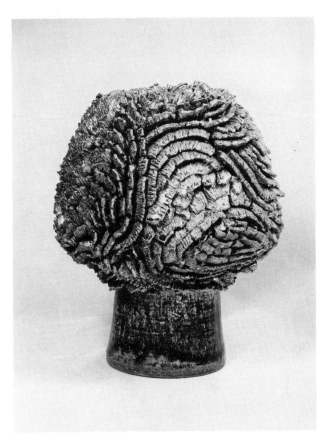

1-4. (a.) Organic ceramic form photographed at f-4/1/15 second. Depth of field is insufficient because the lens opening is too large. (Artist: Elisabeth Schaffer, Germany) (b.) Position of depth of field. Only the front of the object is within the narrow depth of field and appears sharp.

1-5. (a.) The same object photographed under identical conditions at f-11/½ second. The smaller f-stop provides enough depth of field to render the piece sharp. (b.) Position of depth of field.

depth of field

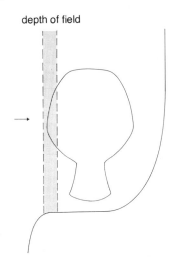

b.

depth of field

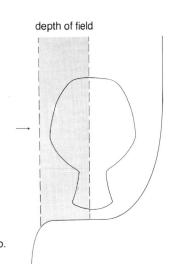

b.

Focal Length of the Lens

Depth of field is modified by a second factor, the focal length of the lens that is used. The depth of field increases as the focal length of the lens becomes shorter (see figure 1-3b). A 35-mm wide-angle lens offers more depth of field than the normal 55-mm lens at the same f-stop; a telephoto lens with a focal length of 135 mm yields considerably less depth of field. The focal length of a lens is engraved on the front of the lens body.

Lenses often have a depth-of-field scale that allows rough calculation of the depth of field corresponding to a specific distance and f-stop. For example, a 55-mm lens has an approximate depth of field of 3 to 4 feet when focused at a distance of 3 1/2 feet with a lens opening of f-16.

1-6. Only part of this ring appears sharp, because the short distance created an extremely narrow depth of field. Photographed with a 35-mm SLR camera and extension tubes. (Artist: Franz Dreyer, Germany)

Distance Between Camera and Object

The third variable influencing depth of field is the distance between the camera and the object (see figure 1-3c). Depth of field decreases as distance decreases. This fact becomes especially important in object photography when smaller objects are photographed from a distance of 5 feet or less. In close-up photography of insects, for instance, at a distance of about 1/2 inch, the depth of field is roughly 1/100 inch even at the smallest possible f-stop.

This is an extreme example, and a craft photographer rarely has to work at distances less than 3 feet. However, when a shorter distance is required, as in jewelry or detail photographs, the smallest possible f-stop should be selected to achieve maximum sharpness. The depth of field at this distance is already so reduced that even with a very small f-stop, part of the background or even of the object itself will be unsharp. The ring in figure 1-6 was photographed at a distance of 5 inches at f-16, but the depth of field was only sufficient to render the main part of the ring sharp.

2

Equipment

In photography, perhaps more than in any other art field, there is a vast assortment of equipment on the market, ranging from the most basic to extremely sophisticated technical devices. The abundance of available tools may persuade some amateurs that mere possession alone will guarantee better photographic results. But while good results in object photography do depend to a certain extent on the quality of the tools and equipment, understanding and control of what you already own combined with a commonsense attitude toward future purchases will prove to be a more effective alternative to accumulating excessive equipment. A thorough look at the possibilities and limitations of your own equipment is the first step towards producing good photographic reproductions of your artwork.

CAMERAS

The most important matter for you to consider is whether your particular type of camera is capable of dealing with the specific photographic problems that arise in your craft area.

First of all, don't blame your camera for your unsatisfactory pictures. In many cases poor quality results from mistakes during the picture taking rather than technical defects or shortcomings of the camera. Whatever camera you use, you should never forget that it is just a tool, and the eye and the mind behind the viewfinder are responsible for the final photograph.

On the other hand, good results cannot be achieved if you are using a camera in photographic situations for which it was not designed. Every piece of equipment has a technical scope that cannot be exceeded without losing quality. It is therefore worthwhile to examine the various camera types commonly used by amateurs today with respect to their suitability for specific tasks in object photography.

The 35-mm camera is the most widely used camera and the center of attention in this book. The basic principles and technical advice are, of course, just as valid for larger-format cameras such as the 2-1/4-inch *single-lens reflex* camera. This camera is a professional tool from the start and has no particular limitations in regard to object photography. The 2 1/4 inch *twin-lens camera,* which is fitted with two identical lenses, one for viewing the scene and one for taking the picture, needs close-up lenses for close-up photography (less than a 4-foot object-camera distance), because of the parallax difference (see below). An exception is the Mamiya 330 or 220 twin-lens camera, which is equipped with an extension bellows and a parallax indicator, thus allowing an object-camera distance down to approximately 1 foot.

In comparing the 35-mm camera with the 2-1/4-inch or larger-format camera, the main advantage of the latter lies in the increased negative format, which is capable of recording more detail. Enlargements made from this larger negative will show less grain and a higher color saturation, an especially important factor for reproduction in books and magazines. It has been a major concern of this book, however, to demonstrate the excellent quality obtainable with the 35-mm format. The various 35-mm cameras on the market show a number of technical differences that are relevant to the photography of art objects. There are three basic types of 35-mm cameras that must be compared:

 viewfinder cameras
 single-lens reflex cameras
 automatic cameras

Viewfinder Cameras
The viewfinder camera is certainly the most universally used camera type. Depending on the technical extras, the mechanical perfection, and the quality of the lens, the price may range from a few dollars for a simple camera to almost a thousand dollars for a Leica.

The camera's distinguishing feature is the separate viewfinder, a window through which the picture appears. At distances of more than 4 feet, this picture is virtually identical with the image that the camera lens "sees" and that is recorded on the negative. At distances of less than 4 feet, however, the difference between the pictures begins to increase, and the picture you see through the viewfinder is not the same as that recorded on the film. This displacement is known as the *parallax* (see figure 2-1). Close-up photographs with a viewfinder camera require a lot of time, patience, and experience, and they exhibit a high failure ratio due to the parallax difference. Although smaller distances are possible with the help of special close-up lenses, it is better to use a single-lens reflex camera and extension tubes (see below) for close-up photography.

Viewfinder cameras often have a range finder, which allows sharp focusing of the object while looking through the viewfinder. Cameras without a range finder can be focused just as precisely by measuring the distance between camera and object with a tape measure and then setting the distance on the camera's distance scale.

A built-in exposure meter is a welcome addition but not absolutely necessary so long as some kind of exposure meter is available.

Although a single-lens reflex camera is often preferred to a viewfinder camera, the latter has one major technical advantage that is of particular interest to the object photographer. Camera vibrations are a major enemy in object photography; any vibrations during a long exposure will cause slightly blurred pictures with a loss of detail. Camera vibrations may be caused externally by knocking against the tripod or internally by the camera mechanism. In most cases, the single-lens reflex camera needs a much firmer and stabler tripod to compensate for the increased internal vibrations caused by its upward-swinging mirror. The viewfinder camera has no swinging mirror, so the shutter opens and closes without vibrations.

Equipped with a good lens, a viewfinder camera will provide excellent results in object photography when used within its normal operating range of 4 to 5 feet and more.

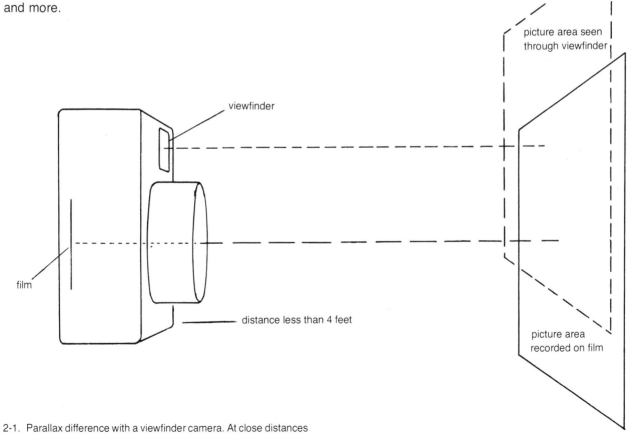

2-1. Parallax difference with a viewfinder camera. At close distances (4 feet or less), the picture area seen through the viewfinder differs from the picture area recorded on the film.

Single-Lens Reflex (SLR) Cameras

The striking difference between the viewfinder camera and the single-lens reflex camera is that in the latter, you actually view the scene through the camera lens itself. This is made possible by a mirror inside the camera body that directs the light rays coming through the lens to the viewfinder. Thus you are actually looking through the lens; the picture you see and the final image on the negative are identical. This makes the SLR camera an ideal tool for close-up photography at distances down to a couple of inches. As there is no parallax difference, taking a correctly cropped photograph that excludes unwanted background is greatly facilitated. This fact gains particular importance when taking color slides, since they allow no further cropping without reduction in size.

In its resting position, the mirror in the body of the camera blocks the passage of light from the lens to the film. During an exposure, the mirror swings up briefly and then returns to its original position. Depending on the brand, this mirror movement can cause considerable vibration inside the camera, which is particularly noticeable during long exposure times. Only a very stable tripod will eliminate the vibration. To avoid this problem, which is particularly unwelcome in object photography, some camera manufacturers offer models that allow the mirror to be locked in its upward position during the exposure. With this improvement, the SLR camera is definitely a superior tool for object photography.

Almost every SLR camera may be used with a variety of exchangeable lenses, from wide-angle to telephoto, which greatly increase its scope and versatility in object photography. The SLR with its standard lens may also be combined with extension tubes to facilitate close-up photography.

The SLR camera allows sharpness, depth of field, and light measurement to be controlled with a maximum of precision and ease.

Automatic Cameras

A great variety of cameras with fully automatic exposure settings are offered on the market, both as automatic viewfinder cameras and as automatic SLR cameras. Some allow both automatic and manual control; others are completely automatic. The fully automatic models can cause serious difficulties in object photography.

Fully Automatic Cameras
Designed for quick shooting, automatic cameras without manual control are actually out of place in object photography, since there is always plenty of time. Most less expensive automatic cameras incorporate only a control lamp, which indicates whether there is enough light for a given film type. Exposure time and lens opening are preset and unknown to the photographer. This eliminates control over depth of field, which is so crucial to object photography.

Nonetheless, satisfactory results can be obtained when the camera is used within its technical limits. Since it is mainly designed for outdoor use, objects should be photographed outside to ensure sufficient light for the automatic exposure control. Objects should not be placed on a background that is considerably brighter or darker than the object itself, as extreme contrast between object and background can misguide the automatic control and cause exposure mistakes.

Automatic Cameras with Partial Control
This type of camera offers either manual control of the exposure time while the lens opening is matched automatically or manual control of the lens opening while the exposure time is matched. With the first type, if the f-stop is not visible inside the viewfinder, depth of field remains highly uncertain. To guarantee sufficient depth of field, pictures should be taken outdoors in the shade on a low-contrast background. Selecting a slow exposure time ensures a relatively small lens opening.

The second type of automatic camera with partial control offers manual selection of the lens opening while the exposure time is automatically matched (from 1/500 second up to 10 seconds, depending on the brand), thus allowing maximum control of depth of field. Mounted on a firm tripod, this type can be used with very good results both indoors and outdoors. As with other automatic cameras, objects should be placed against a low-contrast background to avoid overexposure or underexposure. In contrasty situations the automatic should be switched to manual.

EXPOSURE METERS
Most amateur photographers have and use some kind of exposure meter, either separate from or built into the camera. Although exposure meters perform similarly under ordinary snapshot conditions, their different operating characteristics become important in object photography, since exact light measurement is a critical factor.

Built-in Exposure Meters
Let us assume that all built-in exposure meters measure light reliably enough to guarantee correct exposures. Aside from differences in construction, light-sensitive cells, and other electronic devices, built-in exposure meters may be distinguished by their measuring areas, which vary with different camera types and brands. If you cannot obtain information on the exact measuring area of your camera (usually described in the camera-operation manual), you can determine it through test readings. Place a piece of black paper (about 11 inches by 14 inches) against an evenly illuminated wall and take a reading of just the white wall from a distance of 4 feet, while approaching the black paper. If your exposure meter reacts as soon as the black paper appears in the viewfinder, your camera has an average meter or an average meter with central emphasis. If the meter does not react until the paper becomes visible in the center, your camera has a central spot meter.

Spot and Average Exposure Meters
Some SLR cameras have a central spot meter or separate spot and average metering systems (see figure 2-2a). They allow either a small part of the picture area (spot) or the entire area (average) to be measured.

The object photographer often has to take separate exposure readings of small areas within a larger object or small objects in front of a contrasty background to avoid exposure mistakes. The spot meter system is a valuable and accurate tool with which you can measure just the light reflected from an object or an important area within an object without having to move the camera closer to it.

Average Exposure Meters

Most SLR cameras have only average exposure-meter systems. They measure the entire picture area visible through the viewfinder or a large portion of it (see figure 2-2b). Exposures are correct as long as the entire picture area shows an average distribution of bright and dark tones. If a close-up reading is required, for a high-contrast setting, for example, simply move the camera closer to the object, take a reading, set the exposure, and return the camera to its tripod. See Chapter 5 for more information on close-up readings.)

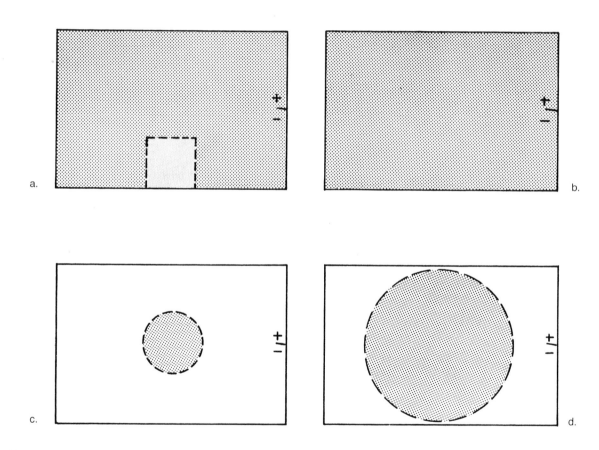

2-2. Basic measuring areas of built-in exposure meters of 35-mm cameras. (a.) Average and spot meter system of a SLR camera. (b.) Average measuring system of SLR camera (identical with picture area). (c.) Center-weighted system of SLR and viewfinder cameras. (d.) Circular measuring area of a viewfinder camera with 30-degree light-acceptance angle and 55-mm lens.

Center-weighted Meters

Some SLR cameras have a sophisticated variation of the average meter system that emphasizes a central measuring area (see figure 2-2c). Although relatively small compared to the entire picture, this area accounts for about 60 percent of the total exposure reading. A center-weighted system facilitates correct exposure readings in contrasty situations, since it can be pointed at the dominant picture area. However, additional close-up readings will increase the reliability of the exposure readings obtained with this system.

Exposure Meters in Viewfinder Cameras

Viewfinder cameras vary in the areas that they measure, depending on the light-acceptance angle and the construction of the meter cell. Check your instruction booklet to find out the measuring area of your camera. If, for instance, your viewfinder camera is equipped with a 55-mm lens and a meter with a circular, 30-degree light-acceptance angle, the measuring area would lie exactly within the picture seen through the viewfinder (see figure 2-2d). Lenses with shorter focal lengths (less than 55 mm) cover a larger picture area, while the measuring area remains the same. This kind of measuring system provides an average reading of most of the picture area and gives a correct reading if there is an average distribution of light and dark tones within the measuring field. Close-up readings can be taken by moving the camera closer to the object.

Exposure Meters in Automatic Cameras

The exposure meters of automatic viewfinder or SLR cameras usually give an average or center-weighted reading. Extremely dark or light backgrounds, which can mislead the exposure meter, must be avoided. The main drawback of many fully automated cameras lies in the fact that they don't allow close-up readings in contrast situations. If a close-up reading taken from a short distance is not preserved when moving the camera back to the original position, correct exposure is possible only when the picture area shows an average distribution of light and dark tones.

More sophisticated automatic cameras do preserve a close-up reading and even tell you which exposure setting has been selected. In this case, you have full exposure control just as with a manually adjustable camera, and correct exposure may be obtained even in difficult situations.

Hand-held Exposure Meters

The separate, hand-held exposure meter is still the professional tool for precise, easy exposure control, since it allows quick changes among average, close-up, and spot readings. It usually offers both reflected- and incident-light readings. (See Chapter 5 for more information on light reading.) Long exposure times of several seconds or minutes and the matching lens openings can be easily calculated.

The measuring area of a hand-held meter depends on its light-acceptance angle, which is 30 degrees on most models. When pointed at the scene from the camera position, the circular measuring field lies exactly within the picture area as seen through a 35-mm camera with a 55-mm lens (see figure 2-3a). A smaller measuring area for close-up or spot readings can be gained by moving the meter close to the object while the camera remains on the tripod (see figure 2-3b).

If your camera does not have a built-in meter, you should definitely consider buying a hand-held one. An exposure meter equipped with a diffusor for incident-light reading and a choice of angles, 30 degrees for average and 15 degrees for spot readings, is very helpful for object photography. Some meters have a small viewing window that shows the exact measuring area. Such a meter will give you perfect control in very critical and difficult lighting situations such as determining exposures for jewelry on dark backgrounds.

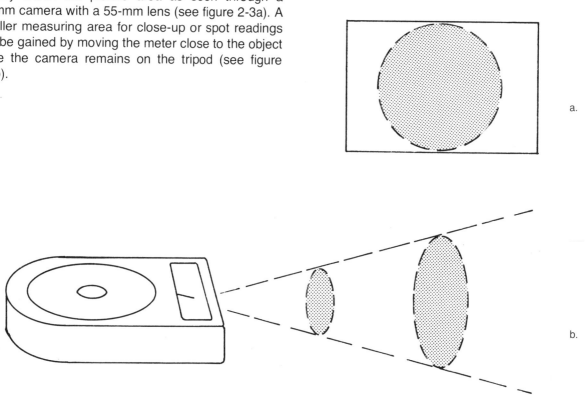

a.

b.

2-3. Measuring area of a hand-held exposure meter. (a.) Circular measuring area of a meter with 30-degree light-acceptance angle fills the viewfinder frame of a 35-mm camera with a 55-mm lens when pointed at the scene from the camera position. (b.) The size of the measuring area is decreased by taking the meter closer to the object.

ACCESSORIES

The wide field of accessories should be entered with care. In general, I try to work with a minimum of accessories and decide on new items only after the need has come up regularly in my photographic practice. The accessories discussed in this chapter are ones that I found to be very helpful in photographing the great variety of objects illustrated in this book. However, the individual artist working in a particular craft will need only what is useful for that type of object photography with its limited technical problems.

Lenses

Lenses are grouped into three categories, according to their focal lengths:

 wide-angle
 normal
 telephoto

Wide-angle lenses have a shorter, telephoto lenses a longer focal length than the normal lens. The focal length of the standard lens on the 35-mm camera is 50 mm or 55 mm. This information, along with the maximum aperture, is engraved on the front of the lens (for example, f-2.8 / 50 mm).

Wide-angle Lens

A wide-angle lens between 28 mm and 35 mm is, next to the normal lens, most likely to be used in object photography. This lens, with its shortened focal length, offers increased depth of field while at the same time widening the range of the picture frame considerably. This enables you to photograph a very large piece in its entirety from a relatively short distance, a definite advantage when one is restricted to small showrooms (see figure 2-4).

2-4. A wide-angle lens was needed to photograph this very large tapestry (8 feet by 4 feet), since only a short distance was available. (Artist: Else Bechteler, Germany)

Telephoto Lens

A telephoto lens is designed for photographing subjects from a great distance; the lens is essentially a telescope that brings the subject up to the camera. This is fine for news or wildlife photographers who cannot always get close to their subjects, but object photographers, however, are generally able to approach their subjects, making this lens unnecessary.

A 90-mm to 135-mm lens may be used to reduce distortions that occur when photographing one or more objects from above (see figure 7-9). However, some detail definition is lost at a greater distance, and the decreasing depth of field becomes a disadvantage when one is photographing three-dimensional pieces. Therefore, it is advisable to stay with the normal lens as long as possible. Telescopic lenses (90- to 135-mm focal length) can also be used in close-up photography of very small objects (see Chapter 9). Used in combination with extension tubes or extension bellows (see below), they increase the often minimal working distance between camera lens and object (see figure 8–8).

Macro Lens

For the photographer of small objects such as jewelry, a macro lens (focal length varies between 20 mm and 150 mm) is worth considering. This special lens is designed and corrected for close-up photography, and it allows small objects to be recorded up to life-size. When used on a SLR camera, focusing and exposure control are easy to handle.

Extension Tubes and Extension Bellows

For occasional close-up photography, a less expensive solution is to use extension tubes (see figure 2-5). Extension tubes, mounted between the camera body and the lens, allow you to photograph at extremely short distances — even down to a couple of inches. A very small object can be recorded life-size, but with somewhat less quality than with the specially corrected macro lens.

Extension tubes usually come in a set of three separate tubes of different lengths, which may be used individually or in combination with one another. To mount an extension tube, remove your regular lens, mount one or more extension tubes into the lens socket of your camera, then remount your lens onto the tube. The further the tubes extend, the closer you can come to the object. When photographing with extension tubes, the smallest f-stop should be selected and the focusing ring of the lens set to infinity. Focusing is best done by moving the object toward the camera until it is sharp. Light reading is controlled as usual.

Instead of extension tubes, the more expensive extension bellows can be used. Its main advantage is that the distance between lens and camera can be changed gradually. This enables you to steadily increase the degree of magnification. Only a limited number of magnifications are possible with a set of extension tubes.

2-5. Close-up view of a mechanical doll (14 inches high), taken with the aid of extension tubes on a 35-mm SLR camera with a standard lens. It was photographed outdoors in diffused light to reduce reflections from metallic parts. (Artist: Serge Komaigorodsky, France)

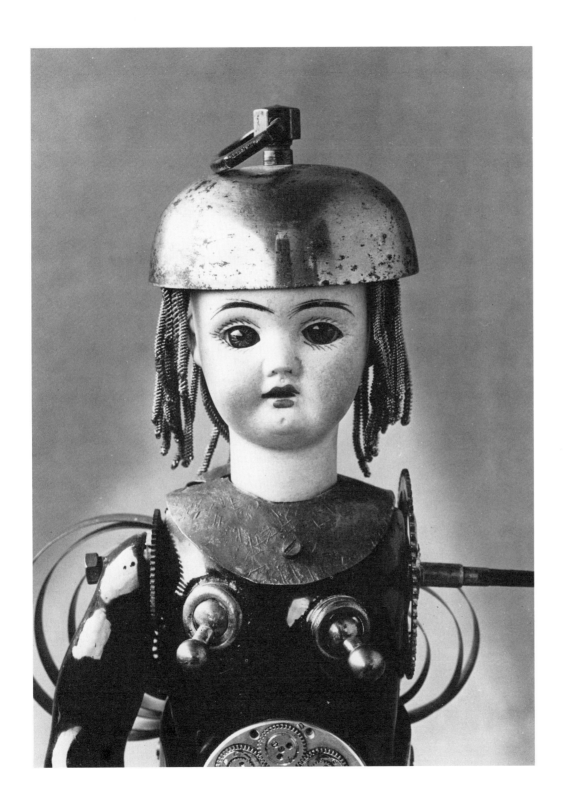

Polarizing Filter

A polarizing filter can be a valuable tool in both black-and-white and color photography. This filter reduces or eliminates reflections and glare from polished, non-metallic surfaces, such as plain glass, enamel, glazed pottery, or polished leather. Reflections from round surfaces cannot be completely subdued, but minor reductions are often possible.

The filter consists of two glass filters, which are turned against each other until reflections disappear. Since this is done while looking through the filter, a SLR camera greatly facilitates its use. You simply mount the filter onto your lens and turn it while looking through the viewfinder. The SLR camera also compensates for the increased exposure necessary with a polarizing filter.

Reflections from metallic surfaces can be eliminated by using polarizing filters in front of both the camera lens and the light source, but polarizing filters large enough to cover photo lamps are very expensive.

Tripods

A firm, reliable tripod is an absolute necessity for quality work in still photography. The general rule that blurring does not occur at exposure times of 1/60 second and faster has little relevance for this type of photography, where longer times are called for. Fine-grain films hardly allow exposure times of more than 1/30 second, perhaps 1/125 second outdoors in full sunlight. Moreover, at the close distance from which many objects are photographed, the slightest camera movement may cause minute blurs and unsharpness. A stable tripod eliminates the movement that certainly would occur if the camera were held in the hand. SLR cameras, which tend to have relatively hard shutter and mirror movements, need a very stable tripod to back the internal vibrations.

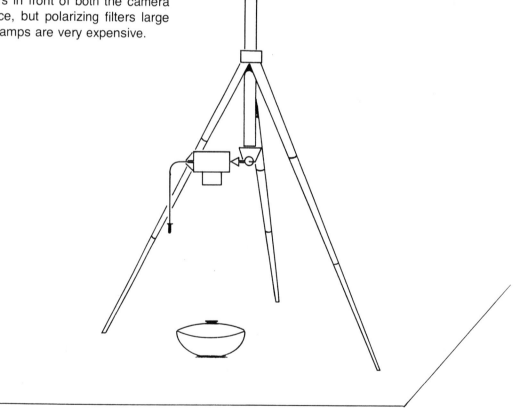

2-6. A camera in table-top position requires a stable tripod with an invertible vertical shaft.

Lack of sharpness because of camera movement during exposure is not the only problem that a tripod has to solve in still photography. A good picture should have overall sharpness of the object, even lighting, a minimum of distracting shadow, no interfering elements in the background, no dazzling glares, and, of course, good composition. To control all these factors while holding the camera in your hand is close to magic. The essential advantage of a tripod is that it allows you infinite time for controlling every adjustment and rechecking all the vital factors in taking a perfect picture.

Since many amateurs do not own a tripod, I should describe the relevant characteristics for still photography. The most important consideration is the stability of a tripod, which should be greatest where the camera is mounted. Manufacturers show a definite trend toward lightweight tripods, but heavier models tend to be more reliable and stable.

Before buying a tripod, test its stability by mounting your camera and placing an object on it that is only in a temporary balance, such as a pencil. Watch the pencil while pushing the cable release to open the shutter; if it moves or falls off during the exposure, the tripod is not suitable for your camera.

The tripod should have as few knobs and adjustable elements as possible to retain the original stability. The mounting should allow movement of your camera in any direction with one easy grip, and the tripod should have a central shaft that can be moved up and down without difficulty. Tripods with a central shaft usually allow inversion of the shaft (figure 2-6), thus making it possible to photograph smaller objects from above (see figure 2-7).

Cable Release

A cable release, screwed into the release button of the tripod, allows the shutter to be released without the extra vibrations caused by the hand at the time of exposure. The self-timer built into many 35-mm cameras can also be used, but in the long run a cable release, which is inexpensive, is more convenient.

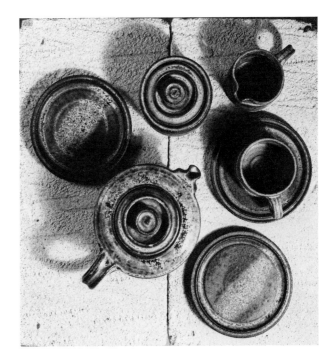

2-7. Table-top view of the coffee set shown in figure 4-3.

3.

Film

Photographing different objects in different situations of course calls for different kinds of film. Choosing the right kind of film is not a question of brands — this is a matter of personal preference — but a question of film type. For example, objects containing extremely bright tones next to very dark ones, such as the vase shown in figures 3-4 and 3-5, require a film that records this high contrast while retaining the details. On the other hand, objects with a rather monochrome tonal range, like the pieces shown in figures 3-2 and 3-3, need a different type of film to increase this low contrast. Selecting the wrong kind of film for a certain situation may seriously impair the quality of the final print.

Familiarity with the various types and characteristics of black-and-white film (see figure 3-1 and Table 1) is your best guide toward proper film selection. (Color film is discussed in Chapter 6.) The same types of film are used in object photography as in general black-and-white photography. The relevant film characteristics are:

 speed
 grain
 contrast

SPEED

One basic distinction among film types is their sensitivity to light, or their *speed*. The speed of any film, regardless of its manufacturer, may be categorized as:
 slow
 medium
 high

The speed of a given film is indicated on the film package in ASA and/or Din numbers, which signify the light sensitivity of the film emulsion. The respective ASA/Din numbers for these three categories are:

slow:	ASA 25–40, Din 15–17
medium:	ASA 64–125, Din 19–22
high:	ASA 400–1600, Din 27–33

Higher numbers indicate a greater sensitivity or higher speed; lower numbers, a slower speed. When the ASA number doubles, the film speed doubles as well.

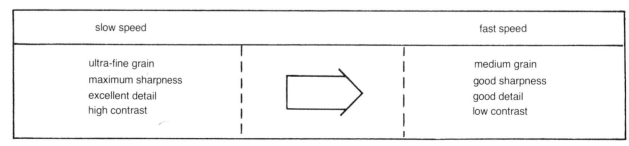

3-1. Film characteristics change with increasing film speed.

TABLE 1

Black-and-white Film.

1. Slow-speed film

a. Characteristics:

Grain	extremely fine, almost invisible
Contrast	hard
Sharpness	excellent
Degree of enlargement	from a 35-mm negative up to 8 inches by 10 inches

b. Suitability for objects:

Objects with low contrast will record extremely well. Contrasty lighting, particularly direct sunlight or hard, nondiffused artifical light, should be avoided. Objects with a high contrast require extrasoft lighting in combination with soft development of film (see Chapter 9).

Brand	Speed	Sizes
Kodak:		
Panatomic-X	ASA 32	35mm: 135-20 exposures 135-36 exposures
		roll film: 120
Ilford:		
Pan F	ASA 25 w. Perceptol ASA 50 w. ID-11 ASA 80 w. Microphen developers	35mm: 135-20, 135-36
Agfa:		
Agfapan 25 Professional	ASA 25	35mm: 135-36 roll film: 120
Isopan IF	ASA 40	35mm: 135-20, 135-36 Rapid roll film: 120, 127

2. Medium-speed film

a. Characteristics:

Grain	fine
Contrast	normal
Sharpness	good
Degree of enlargement	4-inch-by-5-inch prints from a 35-mm negative. Grain begins to shown on 8-inch-by-10-inch format.

b. Suitability for objects:

For objects with medium contrast up to a contrast range of 1:4. Harsh direct sunlight or artificial light should be avoided. Objects with a contrast range exceeding a 1:4 ratio require soft lighting in combination with soft development (see Chapter 9).

Brand	Speed	Sizes
Kodak:		
Plus-X	ASA 125	35mm: 135-20, 135-36
Verichrome Pan	ASA 125	roll film: 120, 620, 120, 127, 828
Plus-X Pan Professional	ASA 125	roll film: 120, 220
Ilford:		
FP4	ASA 64 w. Perceptol ASA 125 w. ID-11 ASA 200 w. Microphen	35mm: 135-20, 135-36 roll film: 120, 620, 127
Agfa:		
Agfapan 100 Professional	ASA 100	35mm: 135-36 roll film: 120
Isopan ISS	ASA 100	35mm: 135-20, 135-36 Rapid roll film: 120, 620, 127

3. High-speed film

a. Characteristics:

Grain	fine to medium
Contrast	soft
Sharpness	good
Degree of enlargement	from 35-mm negative, grain becomes noticeable in sizes over 4 inches by 5 inches; from 2¼-inch negative up to 8 inches by 10 inches.

b. Suitability for objects:

Because of its grain factor this film type has limited use in object photography. Well suited for photography of moving objects, such as mobiles or kinetic art, work in progress, artist at work, and available-light photography requiring faster exposure times.

Brand	Sizes	Speed
Kodak:		
Tri-X Pan	ASA 400	35mm: 135-20, 135-36 roll film: 120, 620, 126, 127
Tri-X Pan Professional	ASA 320	roll film: 120, 220
Royal-X Pan	ASA 1250	roll film: 120
Ilford:		
HP4	ASA 200 w. Perceptol ASA 400 w. ID-11 ASA 650 w. Microphen	35mm: 135-20, 135-36 roll film: 120, 127
Agfa:		
Agfapan 400 Professional	ASA 400	35mm: 135-36 roll film: 120
Isopan Ultra (ISU)	ASA 400	35mm: 135-36 roll film: 120

Note: this list is limited to films I have been using for a long time. Try these or others to find out which brand is best for you. If you are satisfied with one brand, stick to it to maintain constant results. The film speed indicated is recommended by manufacturers for standard development. When it becomes necessary to expose film for different speeds in order to modify the film contrast, be sure to let your processor know by attaching a note to the film. Some developers such as Promicrol by May & Baker or Emofin by Tetenal allow exposing film for twice the recommended film speed.

A high-speed film needs much less light to record a well exposed image, thereby allowing a shorter exposure time or a smaller lens opening than a slow film. In an identical lighting situation, a slow film requires more light and thus a longer exposure time or a larger lens opening. For example, a slow, 25-ASA film may require an exposure of 1/30 second at f-5.6; a 50-ASA film, which is twice as fast, an exposure of either 1/60 second at f-5.6 or 1/30 at f-8; a medium-speed, 100-ASA film, an exposure of 1/125 at f-5.6 or 1/30 at f-11 (provided the lighting situation remains constant). The ASA factor becomes important when photographing moving objects, suspended hangings, or mobiles, where a medium- or high-speed film may be necessary to "stop" the motion with a very short exposure time (see figure 9-17).

In object photography, the exposure time is usually of minor importance, since the subject is static and the tripod allows for exposure times of any length. A slow film is therefore a frequent choice of the object photographer. Sufficient depth of field, which requires a small lens opening, may be combined with the fine-grain texture only a slow film can offer by extending the exposure time.

3-2. Detail of *Aporia,* a woven, fiber object. To record the fine texture detail in this predominantly dark piece, a contrasty, ultra-fine-grain, slow film, Panatomic-X (ASA 32), was chosen. (Artists: Song and Maryn Varbanov, Bulgaria)

GRAIN

The *grain* of a film is directly related to its speed and plays a great role in determining the quality of the final picture. The surface of a film is covered with a light-sensitive emulsion consisting of a myriad of silver crystals, which turn into black dots during exposure and development. The size of these crystals determines the fineness of the grain that appears in the final picture.

Medium- or high-speed film emulsions contain larger crystals, which begin to show in enlarged prints as increased graininess. In a very big enlargement, a black line will appear as a series of bigger and smaller black dots. Slow films have the finest grain, which is almost indiscernible to the eye. It is obvious that the finer the grain, the sharper the lines in the photograph will be. Therefore, slow, fine-grain films result in increased sharpness — a very important characteristic for object photography.

Slow, fine-grain films also allow maximum enlargements: the standard 8-inch by 10-inch enlargement will show hardly any grain. These two features — minimum grain, maximum sharpeness — make slow-speed film the most likely to be used under standard conditions.

3-3. Close-up photograph of *Euphorbia,* a knotted structure in wool and silk. The exposure reading from this predominantly white piece was increased by selecting the next slower exposure time. (Artist: Bonny Schmid-Burleson, U.S.A.)

CONTRAST

The range between very dark and very light tones in a motif is known as *contrast*. The human eye can scan a far greater contrast range than any film emulsion, and the emulsion's contrast range is in turn much larger than that of photo paper. The range of contrast in a negative is therefore of paramount importance for a good print.

Like grain, contrast is also closely related to the speed of the film. A slow-speed film will record only a narrow range of contrast. When photographing a low-contrast scene (absence of extremely bright and dark areas), the slow-speed film is excellent; it will record all details with extreme sharpness and accuracy. Only a hard, slow-speed film could have recorded the nuances of shadings in figures 3-2 and 3-3.

This contrast factor, however, limits the applicability of slow-speed film. When photographing an object with a high contrast between light and dark areas, the slow-speed film will record the light areas as very white with no detail definition, while the dark sections will appear as almost solid black. Figure 3-4 illustrates a high-contrast scene photographed with a slow-speed film. Since a film's contrast range and ability to record detail in both light and dark areas becomes greater with increasing film speed, a medium-speed film should be selected when you are faced with a high-contrast situation. Figure 3-5 illustrates the same scene photographed with a medium-speed film. (See Chapter 9 for further details on reducing contrast.)

3-4. The contrast range between dark and light areas within this ceramic vase was too large for the ultra-fine-grain film (Kodak Panatomic-X) used for this photograph. (Artist: Renate Etzler, Germany)

3-5. The same ceramic vase photographed under identical lighting conditions with a medium-speed film (Agfa Professional 100). The increased contrast range of the film allows both dark and light areas to be recorded.

4
Light

Light as part of our physical environment can become a highly sophisticated tool in the hands of the object photographer. It is primarily through the quality and direction of light that the characteristics of an art object — its form, structure, texture, and color — are transmitted and recorded. This chapter is primarily concerned with the use of light in black-and-white photography. Specific light problems in color photography are discussed in Chapter 6.

NATURAL LIGHT
Natural light outdoors is either *direct sunlight* or indirect, *diffused light* in the shade or on an overcast day. Natural light indoors is known as *available light*.

The sun is a fixed light source, its angle of radiation and the quality of its light depending on season, time of day, and weather conditions. Unfortunately, few artists make use of the outdoor "studio" provided by the sun. The amateur who does not own sufficient lighting equipment may get much better results outdoors, particularly when larger areas such as tapestries must be evenly lit.

Direct Sunlight
Direct sunlight provides a high-intensity, even illumination over picture areas of any size. Depending on the angle of the rays, direct sunlight can be a very hard, contrasty type of light, casting deep and clearly defined shadows. This characteristic makes direct sunlight particularly suitable for flat objects with moderate surface texture (see figure 4-1). It is much less appropriate for three-dimensional objects, as it causes deep shadows that will obscure or eliminate fine detail.

4-1. Fiber construction photographed in direct sunlight at noon. The hard, contrasty sunlight emphasizes the graphic pattern of the rope twist and the background. To avoid excessive contrast, a medium-speed film, Kodak Plus-X, was necessary. (Artist: Dorris Akers, U.S.A.)

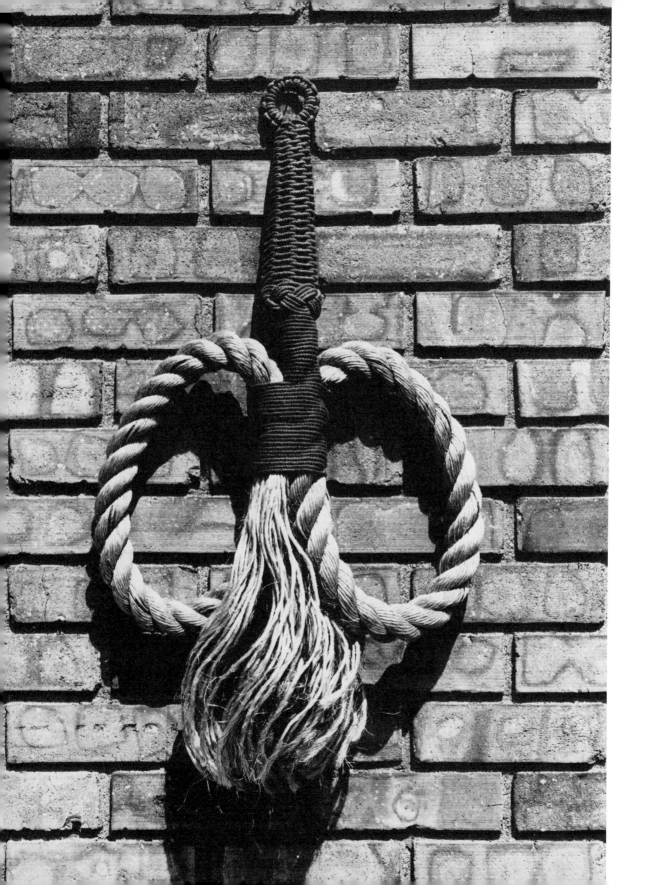

Diffused Light

In diffused light, the rays of the sun are no longer parallel to each other as in direct sunlight; they are spread out and strike an object from many directions. This condition is present whenever the sun is hidden behind clouds or in the shade of a large object such as a house. Photographing in the shade of a tree should be avoided, as it will cast uneven shadows.

Diffused light softens shadows and helps to reduce the contrast between light and dark areas. It is ideal for three-dimensional and contrasty objects, since it reduces the harsh shadows and high contrast that would occur in direct sunlight. Diffused natural light also reduces reflexes on shiny objects such as metal or ceramic glazes. Glass, polished metal, and other highly reflecting objects may still reflect their surrounding environment; if so, they will require the use of a light cage (see figure 8-5).

Available Light

Available light is diffused daylight coming through a window. Generally speaking, it should not be used when even distribution of light over a larger area (more than 1 square foot) is called for. However, three-dimensional objects such as pottery or sculpture may gain a special emphasis when photographed in available light (see figure 4-3). Direct sunlight shining through a window should be avoided, since it is extremely hard and rarely yields satisfactory results. Shadow areas should be brightened with a reflector board to reduce contrast and to preserve detail. (A reflector board used in this manner is illustrated in figure 4-9.)

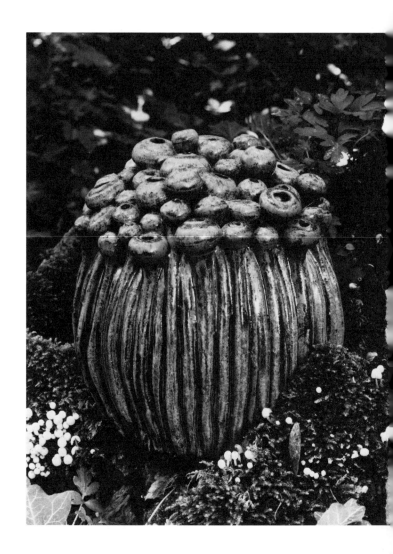

4-2. An overcast day provided the diffused light necessary to photograph the shiny glaze on this ceramic form in a natural setting. The main light coming from above was balanced by a reflector board, which lit the base of the piece sufficiently to record detail. The relatively high contrast of this scene required a medium-speed film, Agfa Professional 100. (Artist: Barbara Schwaemmle, Germany)

32

4-3. Available light from a north window provided the soft, harmonious illumination for this ceramic coffee set. To compensate for the diminishing light intensity towards the left and to brighten shadows, a large reflector board was used. A minimum f-stop of f-16 provided sufficent depth of field to render all objects sharp. (Artist: Elisabeth Schaffer, Germany)

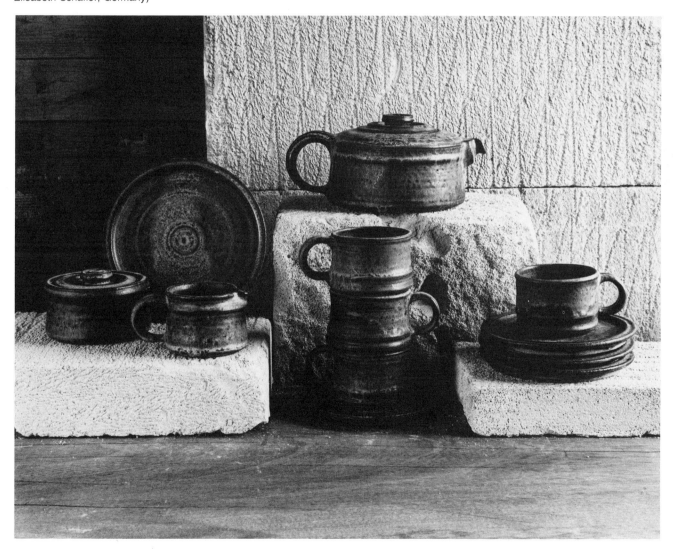

ARTIFICIAL LIGHT

The great versatility of an indoor studio equipped with artificial light is obvious. It frees you completely from all the weather hazards that sometimes make working outside a frustrating experience. One of the main advantages of artificial light is its mobility — it allows precise positioning of highlights and shadows on a piece. For this reason, three-dimensional objects, which are mainly defined by highlights and shadows in black-and-white photography, are best photographed indoors.

Setting up your own indoor studio need not run you into debt for years. After all, you don't have to reserve a special room, and you don't need a sophisticated, high-capacity studio-light unit. Art, not photography, is your professional field. Almost any room in your apartment, house, or studio and most general household furniture will be sufficient to set up a simple, temporary indoor studio capable of handling your limited photographic problems. The lighting in your studio needs your closest attention, since it will largely determine the quality of your photographic reproduction.

Basic Lighting Equipment

Artificial light is produced by an electric tungsten light bulb, preferably of 500 watts. Although light units with a higher energy output are on the market, several 500-watt bulbs in reflector bowls are a relatively inexpensive and easily manageable and maintainable artificial-light source.

Photo lamps are available in two color temperatures, 3200 Kelvin and 3400 Kelvin. The color temperature of a lamp is irrelevant to black-and-white photography — it becomes important only in color work: the color temperature of the film and the bulbs must be matched. (See Chapter 6 for further details on color temperature in color photography.)

Mobility of your light source is a prime requirement for good lighting. The most inexpensive way to assure this is to use several (up to four) aluminum clamp-on reflectors. They accept bulbs up to 500 watts and can be clamped onto chairs, tables, doors, and the like, making them ideal for on-location shooting.

Light stands that carry a turnable lamp reflector are a more efficient alternative when working with more than two lamps. I have worked with a combination of two clamp-on lamps and two reflector lamps on stands, each with a 500-watt bulb, and found this to be a versatile, low-budget light setup. Inexpensive, simple light stands with aluminum reflector bowls may be purchased in photo-supply stores, and clamp-on lamps are also readily available in hardware and department stores.

Indoor lighting setups vary according to the type of object that is to be photographed. Flat objects need two or four lamps, depending on their size. The lamps should have bulbs of equal wattage and should be placed at equal distances from the object to guarantee even distribution of light. With three-dimensional objects, the photographer should work with one main light source, which is balanced and supported by additional fill-in lamps to brighten shadows, light the background, or provide extra highlights. (More information on specific lighting setups for various types of objects is found in Chapter 9.)

Some objects may require a modification or an increase of this basic lighting setup, and this may become rather expensive if you buy on a professional level. Unless you use the additional lighting equipment discussed below frequently and regularly, it is more economical to build some of it yourself in order to increase the versatility of your photo studio.

Diffusing Screens

Diffusing screens break up the almost parallel rays of direct light. Whereas direct artificial light is very hard and contrasty, casting strong, clearly defined shadows, diffused artificial light, referred to as "soft," reduces contrast and casts soft shadows without distinct outlines. The ceramic form in figure 4-4 was photographed with the aid of diffusing screens.

Although diffusing screens that can be attached to the reflector bowl are commercially available, even professional photographers tend simply to use sheets of tracing paper, which can be attached to the reflector bowl with a wooden clothespin (see figure 4-5). The great heat emitted from a 500-watt bulb will singe this paper, however, if the lights are left on for more than a minute or two, and plastic clothespins may start to melt. A safer and more heat-resistant device for attaching tracing paper to a reflector bowl, which can be constructed within an hour, is demonstrated in figure 4-6.

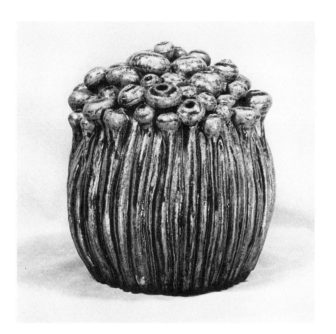

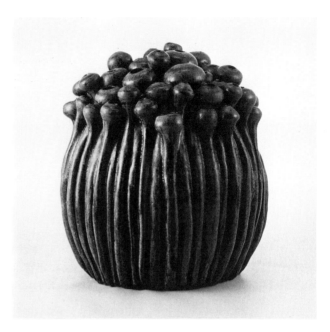

4-4. The ceramic form shown in figure 4-2 was photographed on gray velvet with three screened lamps. The diffused light softens the shadows cast by the lamps while retaining highlights and sparkle on the glaze.

4-5. The mood of the same ceramic form was completely changed by photographing it in a light cage on a seamless, tracing-paper background. The reduced reflectivity and the absence of highlights invoke a soft, subdued feeling. The object was lit from all sides, with a dominant light from the left; lighting from below eliminated all but a trace of shadow.

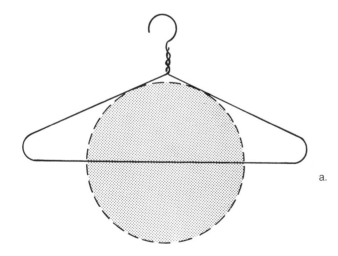

a.

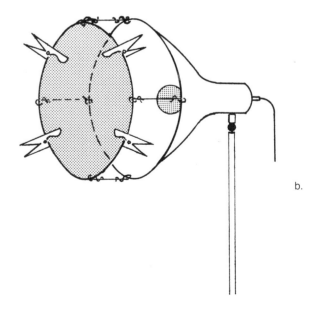

b.

4-6. Building a diffusing screen. (a.) Bend a coat hanger into a circle to serve as a frame for the screen. (b.) Drill four holes in the reflector bowl, then attach the circular hanger with three thin wires. A circle of tracing paper can be fastened temporarily with wooden clothespins at a distance of 5 inches from the light bulb.

Light Cage

Objects with shiny, highly reflective surfaces, such as glass, some jewelry, polished silver, or high-glaze pottery, need a special lighting approach to eliminate unwanted and distracting reflections from lamps and surrounding objects. Simply diffusing the light with screens is not always sufficient, as the lamps, and even the camera or the photographer, often continue to be reflected in the surface of the object. An opaque *light cage* or *tent* that completely encloses the object, leaving an opening only for the camera, is the professional solution.

The cage should be at least twice as large as the object, and, depending on the size of the object, it may be constructed from metal rods (figure 4-7), wooden dowels and joints (figure 4-8), or simply a roll of tracing paper. The frame of the cage must be lined with a light-diffusing material that does not cause color distortions. Some inexpensive materials are white tracing paper, a white percale bed sheet, or white rayon. The light cage may rest on a piece of glass, thus enabling the photographer to light from all sides, including below and above, to ensure completely even lighting. An opening large enough for the camera is left in the covering, through which the light reading is taken with a hand-held meter or a built-in spot meter. When you are photographing highly reflecting objects, such as polished silver, the camera may have to be covered with a white cloth to prevent it from reflecting as a dark spot.

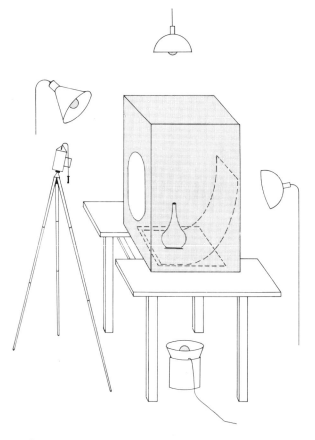

4-7. Studio setup with light cage. The 20-inch by 20-inch by 30-inch cage was built by welding sturdy iron rods together. 50-inch-wide sheets of tracing paper were taped around the inside to exclude reflections from the frame itself. An additional sheet of tracing paper was taped inside to provide the neutral-gray, seamless background shown in figure 4-5. For colored backgrounds, sheets of colored, mat paper can be used.

4-8. A light cage made from wooden dowels and joints can be disassembled after use. Holes are drilled in 2½-inch-square wooden blocks to accept the dowels.

Reflector Boards

Reflector boards are frequently used to reflect part of the light from a single light source such as the sun, a lamp, or available light coming through a window. A reflector board is often used instead of an additional lamp to light up shadow areas, as its light does not cast strong shadows of its own. Figure 4-9 illustrates the use of a reflector board in photographing a ceramic group under available-light conditions.

A reflector board consists of a large reflecting surface of approximately 25 inches by 35 inches. This may be a sheet of white paper or cardboard. When a higher and somewhat harder reflection is called for, a piece of cardboard can be covered with crumpled aluminum foil. The crumpling will assure a relatively diffuse reflection. Mounting the reflector board on an additional light stand will add mobility.

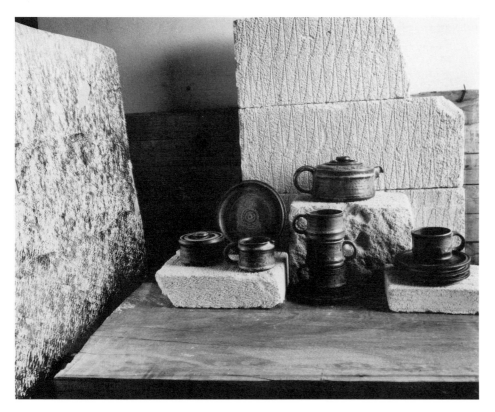

4-9. A reflector board covered with crumpled aluminum baking foil was used to balance light from the right side in photographing the coffee set shown in figure 4-3.

Spotlights
By concentrating light on a small area, spotlights allow precise positioning of highlights and shadows on three-dimensional objects, thus making possible highly effective, dramatic lighting techniques.

In a professional spotlight, a set of lenses concentrates the light rays to illuminate only a small area or spot. A similiar effect can be created with a slide projector and may, in many cases, be preferable to buying an expensive, professional spotlight. To obtain a round or oblong illumination area, simply cut a circle or slot in a piece of black paper and fit it into a common slide frame. The distance from the object and the size of the opening in the slide will determine the area of illumination. You can also unfocus the projection to eliminate sharp shadow outlines and to increase the spot area. The vase in figure 4-10 was photographed with a spot from a slide projector, and figure 4-11 shows the setup that was used.

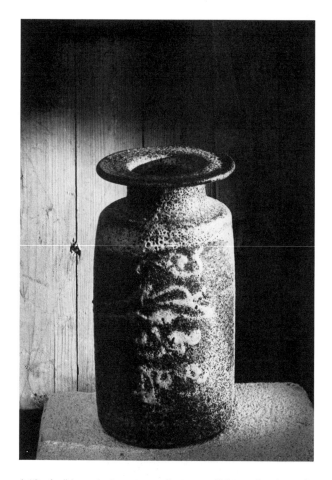

4-10. A slide projector was used as a spotlight to give dramatic lighting and emphasis to the outline of this ceramic vase by juxtaposing the light area on the object with a dark background and vice versa. (Artist: Peter Bell, Germany)

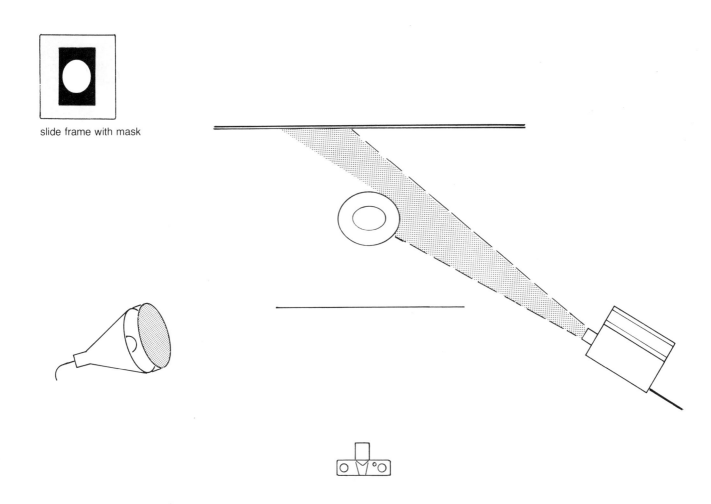

slide frame with mask

4-11. Lighting setup for figure 4-10. The intense spotlight on the right was balanced by an additional light on the left to lighten shadows. The spot effect was achieved with a circular mask in a regular 35-mm slide frame. Projecting out of focus eliminated the sharp outlines of the illuminated spot area.

Barn Doors

Another device that helps you to direct illumination precisely is a set of two adjustable metal shutters, called *barn doors*. These are attached to the reflector bowl and can be opened or closed to control the area of illumination and to prevent light from spilling over to areas that should not be lit (see figure 4-12). They are particularly useful for creating special background illumination that separates the object from its background. The vase in figure 4-13 was illuminated by a lamp equipped with barn doors (the setup is shown in figure 4-14). Barn doors that can be attached to reflector lamps may be bought at photo-supply houses at a fairly low cost.

4-12. A reflector bowl with barn doors that control the area of illumination.

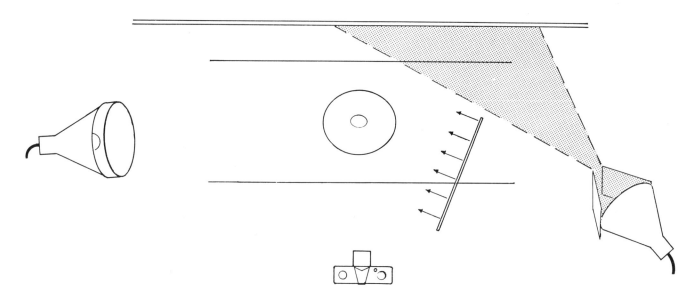

4-14. Lighting setup for figure 4-13. The right part of the background was illuminated by a reflector lamp equipped with barn doors to prevent light from spilling on the object or the left side of the background. The object was lit with a screened lamp on the left, while the shadow area on the right side of the object was brightened by a reflector board.

4-13. Barn doors were used to control the background illumination for this porcelain vase. As in figure 4-10, emphasis of shape was achieved by juxtaposing the lighter side of the object with the dark part of the background and vice versa. (Photograph: Klaus Bauman, Germany; Artist: Hubert Griemer, Germany)

Electronic Flash

A very strong word on one of the most widely used sources of artificial light, the electronic flash. As satisfactory as the flash may seem in general snapshot conditions, it is a very unreliable tool in object photography. Since the effect of a flash is not visible until one views the developed film, it does not offer exact control over highlights and shadows during the actual picture taking. It is also the only light source that cannot be balanced with additional illumination, unless highly sophisticated studio flash units are available. Since black-and-white film works equally well with photo lamps or natural light, there is really no particular reason to use flash. Even without sufficient lighting equipment, the photographer will still have more control outdoors than with a flash.

On the other hand, flash cannot be entirely dismissed in object photography, since there are situations that leave no alternative, such as taking color slides in galleries or exhibitions without the use of photo lamps. Direct flash does work better with flat objects such as tapestries or macramé wall hangings that are not too large and do not cast strong shadows. Direct flash is much less satisfactory for three-dimensional objects, where controlling shadows is essential to define form.

Modern electronic flash units equipped with a computerized light cell allow bounced flash to be used without extra calculations. The reflector of the flash unit is directed at a reflecting white wall, usually the ceiling, while the light cell is directed at the piece. The computerized light cell switches the flash unit off when the object has been sufficiently illuminated. This flash technique can also be applied to three-dimensional objects with a reasonable chance of success.

5

Measuring Light

The decisive step before the final "click" is to measure the intensity of the illumination on your object. This in turn helps you to determine the exact exposure time and f-stop. Medium negative density in a black-and-white film and good color saturation in a color slide or print indicate a correct exposure. Any mistakes made when taking an exposure reading will not become apparent until the negative or slide film is developed. Even minor aberrations from a correct exposure may lead to loss of detail definition or deviations from true color rendition. In extreme cases, underexposure or overexposure may make the photograph completely unusable, thus necessitating a second picture-taking session. An overexposed black-and-white picture is one that received too much light. The negative is very dense, almost black. The resulting print will be too light, with a loss of detail in the bright areas. On the other hand, an underexposure may leave the film virtually untouched by light. The negative is thin, almost transparent, and the print will come out in dark, gray tones with only the lightest parts of the object visible. In color photography, overexposure will produce light, faded-out colors (see figure C-2f), while an underexposure will darken the colors, shifting them towards black (see figure C-2d).

Light is measured with an exposure meter, which either is built into the camera or is a separate instrument. (The various types of exposure meters are discussed in Chapter 2.) The meter must be used for each new object or group of objects and for each slight change in the lighting conditions. A cloud covering the sun, a change in the distance between lamps and object, or the addition of a diffusing screen all necessitate a rereading of the illumination.

While using a meter is a simple procedure that can be refreshed by checking the manufacturer's instruction booklet, the photographer should be aware of the different methods of taking a reading to avoid common measuring mistakes in object photography.

An exposure reading may be taken as either a reflected-light reading or an incident-light reading.

REFLECTED-LIGHT READING

A *reflected-light reading* measures the intensity of the light that is reflected from the object to the meter (see figure 5-1). It is the most frequently applied method for determining correct exposure and can be carried out with all types of exposure meters, whether through the lens, separate from the lens, or separate from the camera. In a reflected-light reading, the meter is pointed at the scene.

An exposure meter does not necessarily guarantee correct exposure. In a reflected-light reading, a correct exposure depends on the measuring area selected, as exposure meters provide an average reading of light and dark tones together. Therefore, only areas with a fairly average distribution of light and dark tones will provide a correct reading.

To understand and apply this principle, you should keep in mind how an exposure meter reads light, or better, how it "sees" the world. You might say that an exposure meter's world is gray. Most objects, of course, are not gray but contain light and dark areas. The light reflected from these areas is added up by the meter and then averaged out in order to provide a reading for a "gray" picture. Naturally, the final photograph is not gray but shows exactly the same dark and bright areas as the original scene.

In most general photography, the entire scene includes light and dark areas that can be averaged out by the exposure meter. In object photography, however, this is very often not the case, and the meter must be pointed at a representative area containing both light and dark tones (see figure 5-2). This measuring area is usually not identical with the entire picture area — in fact, it may fill only a fraction of the frame.

Another measuring principle is to measure only what is visually important, which is generally the object alone. This applies particularly to black-and-white photography with very contrasty dark or light backgrounds. Only when both background and object are equally important, as with a textured background, should the measuring area include a representative portion of the background as well.

To assure a correct exposure, you must ascertain which of the following types of reading is appropriate:
average
close-up
spot

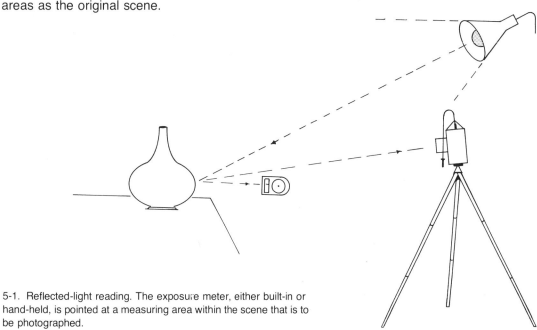

5-1. Reflected-light reading. The exposure meter, either built-in or hand-held, is pointed at a measuring area within the scene that is to be photographed.

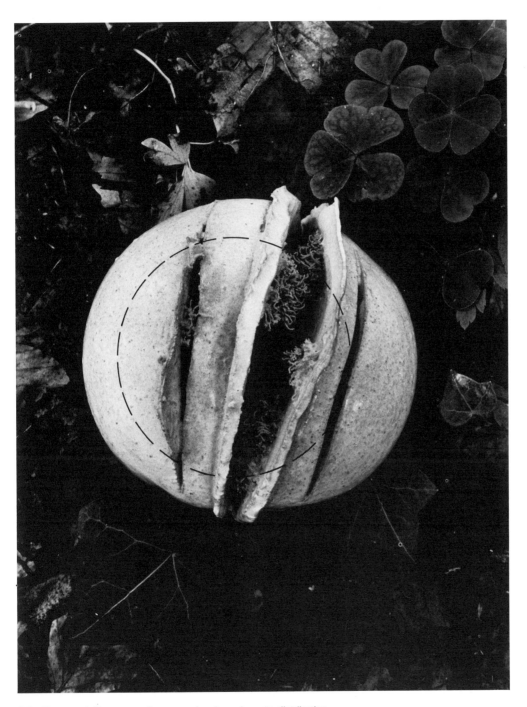

5-2. Representative measuring area, showing adequate distribution
of light and dark tones for a correct exposure. This is a table-top view
of the ceramic form shown in figure 8-6.

45

Average Reading

Cameras with an average meter system read the entire picture area or a large portion of it (see figure 5-3a). To obtain an average reading with a hand-held meter, the meter is held at camera position and pointed at the scene.

In object photography, an average reading will prove satisfactory only if there is a fairly average distribution of light and dark areas or if a general gray tone prevails (see figure 5-4). It is applied primarily when an object fills the entire picture frame or when both background and object are visually interesting. In the latter case, the background should not be considerably lighter or darker than the object.

Overexposure or underexposure frequently occurs when photographing a light object in front of a dark background or vice versa. An average reading of the total picture area will include too much of the background, and the meter will tell you to increase or decrease exposure more than is necessary. A light-colored object on a black background, for instance, will then be overexposed and appear washed out on the print or slide (see figure 5-5). When the entire picture area does not show an average distribution of light and dark tones, a close-up reading of the object is necessary.

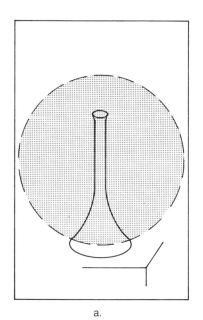

a.

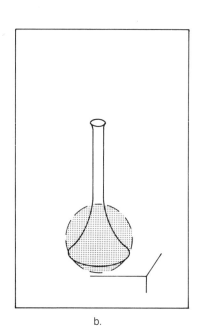

b.

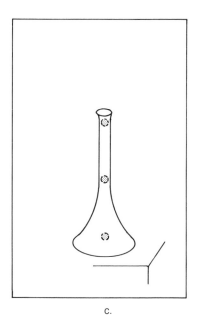

c.

5-3. Three methods of taking a reflected-light reading. (a.) Average reading. Depending on the meter system, either the area within the circle or the entire frame is taken into consideration. (b.) Close-up reading. (c.) Spot readings.

5-4. Silver brooch on a sand background. The overall gray tone allows an average reading for correct exposure of both piece and background. (Artist: Hermann Juenger, Germany)

5-5. Severe overexposure of the object occurs with an average reading of a white object on a dark background. A close-up reading as in figure 5-2 must be taken.

Close-up Reading

In a close-up reading, the exposure meter is held near the object, excluding most or all of the background (see figure 5-3b). Since cameras with built-in exposure meters require moving the camera to the object (see figure 5-6a and b), a separate, hand-held meter is an advantage, since you may leave the camera on the tripod in its original shooting position. Cameras with alternate average and spot meter systems can be used from the original standpoint by switching to spot and aiming the spot-measuring area at the subject (see figure 5-6c).

The smaller, close-up measuring area must also contain an average distribution of light and dark tones, as in figure 5-2. If you are photographing an object on a background that is much lighter or darker, the measuring area should lie within the object. A close-up reading is the most commonly applied method of determining correct exposure in object photography, especially in contrasty situations (see figure 5-7).

The artist, however, does not consciously create objects with an average distribution of light and dark areas ready-made for the camera. You may be interested in exploring brown and black tones or a totally white piece. As the photographer, you must then compensate for your exposure-meter reading in the final adjustment of the camera.

An object that is predominantly white and unbalanced by any dark areas will cause the exposure meter, which is built for average distribution, to overreact: because of the extra light coming from the white area, the meter will tell you to close the camera lens more than you should, and the bright tones of the scene will turn out more gray than white. To compensate for this, it is necessary to increase the exposure indicated by the meter by a full f-stop or to double the exposure time. For example, if a reading from a predominantly white measuring area provides an exposure setting of f-16 / 1/15 second, you should set the camera at f-16 / 1/8 second or f-11 / 1/15 second (see figure 5-8). In general, it is preferable to alter the exposure time in order to maintain constant depth of field.

5-6. Close-up readings with built-in meter systems. (a.) Close-up reading taken with a viewfinder camera with a 30-degree light-acceptance angle and a circular measuring area. (b.) Close-up reading taken with an SLR camera with an average meter system. (c.) Close-up reading taken with an SLR camera with a spot-meter system.

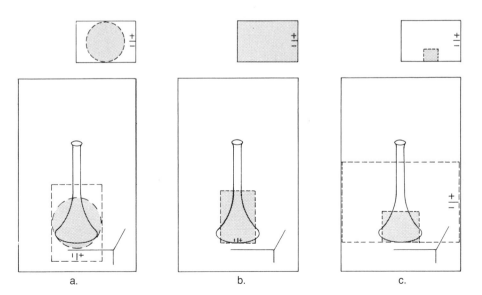

a. b. c.

The other extreme is a reading from a mainly dark scene like the one shown in figure 3-2. Here the next smaller f-stop or a faster exposure time than indicated on the exposure meter should be used. For example, if a reading taken from a dark picture area provides an exposure setting of f-11 / 1/15 second, set your camera at either f-11 / 1/30 second or f-16 / 1/15 second.

5-7. Close-up measuring principles also apply when taking contrasty detail photographs. A close-up reading of the stones in crocheted nets, excluding the black background, was the proper approach to obtain a correct exposure of this detail from figure 7-5.

5-8. Exposure readings from predominantly white objects demand slight overexposure. A close-up reading of this small plaster sculpture provided f-16-1/30 second. The actual exposure was f-16/1/15 second. (Artist: Max Soellner, Germany)

Spot Reading

In a spot reading, the meter system is pointed at the object from a very close distance to reduce the measuring area almost to a true "spot" (see figure 5-3c). In this case, no average light reading is possible; the light and dark spots are read separately and then averaged by the photographer.

A spot reading is preferable in situations where an average or close-up reading is difficult or impossible to attain. For example, the tall, narrow vase shown in figure 5-9 is lighter towards the top and darker towards the bottom. An average reading containing both dark and light tones would not be possible without including too much background, so two or three separate spot readings should be taken and an average exposure chosen. If the readings resulting from a given illumination were f-16/1/8 second at the top and f-16/1/2 second at the bottom of the vase, for example, an adequate exposure would be the intermediate value, f-16 / 1/4 second.

Spot readings are also used to determine the range of contrast within an object and between object and background. Dark and light areas are read separately and should not differ by more than two f-stops. When the contrast range between object and background exceeds this amount in a scene where the background is to be equally represented, simply select a background that is closer in tone to the object. When the contrast within the object exceeds two f-stops, it should be treated as a contrasty object (see Chapter 9).

Gray Card

Whenever it is impossible to obtain a reliable reflected-light reading, as in the case of an extremely small object, a reading should be taken off a neutral gray card with average reflectance, such as the one manufactured by Kodak. This card is placed over the object and parallel to the back of the camera. Provided that the object has an average reflectance, the reading taken from the card will be the same as if it had been taken from the object itself. With highly reflecting objects such as jewelry, close the lens down by the next smaller f-stop and bracket this exposure with at least one underexposure and one overexposure to compensate for the more than average reflectance.

General Measuring Principles

1. Find the correct measuring area of your exposure meter (built-in or hand-held) from your instruction booklet or camera-operation manual.

2. Measure only what is visually important, usually just the object.

3. Select a measuring area that contains both dark and light tones in average distribution. This measuring area need not be identical with the entire picture area. It is much smaller when a close-up reading is taken.

5-9. Glass decanter with cup. Three separate spot readings were taken to control even illumination and to obtain a correct exposure. Average or close-up readings would yield misleading values because of the extreme contrast and shape of the pieces. The scene was illuminated by one main lamp from the top left and an additional fill-in lamp from the lower right to light the base. Careful positioning of the second lamp eliminated disturbing reflexes in the glass. (Artist: Erwin Eisch, Germany)

INCIDENT-LIGHT READING

In an *incident-light reading,* the illumination falling on the object or picture area is measured directly by pointing the meter towards the camera lens (see figure 5-10). Usually only hand-held meters allow for this method. They have a spherical diffuser, generally a small, opaque globe, that can be slid over the meter "eye", thus enabling you to measure the intensity of a light source illuminating the object. In object photography, an incident-light reading is mainly used to control even distribution of light over a flat picture area (see figure 9-7).

BRACKETING

The risk of exposure errors can be considerably reduced by bracketing the actual exposure indicated by your meter with additional exposures. This is usually done by keeping the lens opening constant and selecting the next slower and the next faster time. For example, if the correct exposure indicated by your meter is f-11 1/30 second, take additional exposures at f-11 1/15 second and f-11/1/60 second. Bracketing is also possible by keeping the time constant and selecting the next smaller and the next larger f-stops. However, since maximum depth of field is of crucial importance in object photography, it is best to keep a constant, small f-stop.

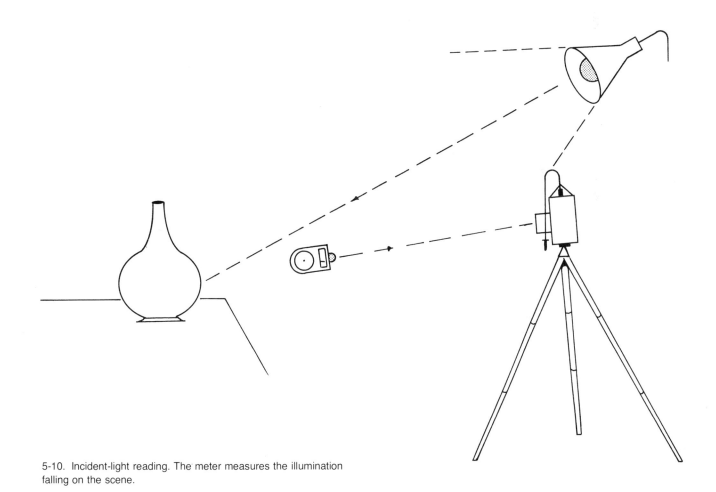

5-10. Incident-light reading. The meter measures the illumination falling on the scene.

LONG EXPOSURE TIMES

The object photographer working with 500-watt bulbs does not usually need to exceed a 1-second exposure. However, when you work with less powerful lights or in circumstances that require a slow, ultra-fine-grain film and maximum depth of field, longer exposures may become necessary. For example, you may want to photograph a piece of jewelry with soft lighting and an ultra-fine-grain film such as Kodak Panatomic-X, rated at 32 ASA / 16 Din. As you need maximum depth of field, you must take the picture with the smallest possible f-stop, which requires a fairly long exposure time exceeding the standard 1-second exposure. A hand-held meter with its wide range of long exposure times can tell you the correct exposure time for this f-stop, but with most built-in meters you will have to calculate it yourself. This is easily done by setting the exposure-time dial at 1 second and opening the lens until you get a correct reading. Then double the exposure time for each consecutive full f-stop until you reach the desired smaller f-stop. For instance, if your built-in meter provides an exposure setting of f-5.6/1 second, the necessary exposure for f-16 would be 8 seconds. Figure 5-11 illustrates the manner of calculation.

To execute the long exposure time, close your lens to the selected f-stop, set the exposure dial to B, and push your cable release down to open your lens while timing 8 seconds. After 8 seconds, release the shutter. Bracket this exposure with at least one longer and one shorter exposure.

When you are using color film, check the film instruction sheet to see which color filters are necessary for long exposures.

f-2.8	f-4	f-5.6	f-8	f-11	f-16	f-22
¼ second	½ second	1 second	2 seconds	4 seconds	8 seconds	16 seconds

5-11. Calculating long exposure times.

6

Color

Color represents a new pictorial dimension and a step towards greater realism in photographing your art object. Obviously, pieces that are mainly characterized by the intricate use of color will be best presented in a color slide or print. This is true not only of bright, colorful creations but also of artwork with very subtle color nuances, as a black-and-white print would record these in shades of gray. However, color is not the ultimate photographic medium for every object; a decision for color should be made after careful deliberation of the advantages of both black and white and color.

From an artistic point of view, the black-and-white print is not necessarily inferior because it lacks the dimension of color. In fact, many photographs of art objects may even lose pictorial impact if taken in color. Black-and-white photography, with its greater degree of abstraction, helps to dramatize elements of form, structure, or surface texture; light and shadow and their subtle interrelationship are its essential factors. Whenever these aspects are predominant and you wish to emphasize them, black and white is the best medium to represent your object.

Practical considerations may also determine your choice of black and white or color. Because of lower reproduction costs, black-and-white prints are always in great demand with magazine and book editors and for gallery shows and catalogs.

On the other hand, 35-mm color slides are ideal for classroom presentation and are often required by art juries. A collection of slides can serve as a practical and effective archive of your work. Color prints from color negative film may be used as an alternative medium for quick presentation when viewing equipment is not available. For photographic excellence, however, the slide is preferable to the print, because it provides brilliant color, fine grain, and extreme sharpness.

With respect to technique, the color photographer applies many of the principles of black-and-white photography. Exposure, f-stop, depth of field, and light measurement are just as valid for color as for black-and-white photography. The one fundamental difference lies in the color of light. This factor and its practical implications are clarified in this chapter.

COLOR FILM

Light is generally considered to be colorless or white as long as it is not divided into its spectral colors. The color photographer, however, has to realize that this is only relatively true and that the actual colors of an object as recorded on film largely depend on the color of the light that illumines it. Natural light outdoors contains a far greater amount of blue than light emitted by a tungsten lamp indoors. The color quality of the light produced by these two sources is so different that there are two distinct types of color slide film. *Daylight film* is balanced for sunlight, whether direct or diffused, and for flash cubes and electronic flash, whereas *artificial-light film* is designed for use with tungsten photo lamps indoors (see Table 2). The importance of coordinating film to light source will become all too visible if the wrong type of film is selected. Daylight film used indoors will show an overall yellow-red cast, whereas artificial-light film used outdoors will show an unnatural bluish cast. Only film balanced for the quality of a given light source will reproduce colors that appear natural.

Color-conversion filters are available that allow you to use daylight film indoors with photo lamps and vice versa. However, these filters are expensive, they constitute an extra piece of glass in front of the camera lens, and they require additional exposure compensation. It should be noted that the light from fluorescent lamps has a different color quality than that from tungsten lamps and cannot be used with artificial-light or daylight film without a special filter.

Color negative film for color prints is usually designed for daylight or flash but may also be used with artificial-light sources, provided the appropriate filter as specified by the film manufacturer is used.

TABLE 2

Color Film.

Slide Film
1. Daylight film

Brand	Speed	Size	Suitability
Kodak:			
Ektachrome-X (EX)	ASA 64	35mm: 135-20, 135-36 roll film: 120, 110-20, 126-20, 127	Good all-around film for outdoor object photography.
High-speed Ektachrome (EH)	ASA 160	35mm: 135-20, 135-36 roll film: 120, 126-20	Necessary only for photographing moving objects outdoors, such as mobiles or pieces on a model.
Kodachrome 64 (KR)	ASA 64	only 35mm: 135-20, 135-36	High-quality slide film with medium film speed, suitable for still objects.
Kodachrome 25 Daylight (KM)	ASA 25	only 35mm: 135-20, 135-36	Ideal for object photography because of its superior color rendition and extreme sharpness. Low film speed requires a stable tripod.
Ektachrome Professional Daylight (EP)	ASA 50	only roll film: 120, 220	An excellent film for consistently fine results. Film requires processing without delay.
Agfa:			
Agfachrome 50 S Professional	ASA 50	135mm: 135-36 roll film: 120	Excellent for outdoor object photography.
Agfachrome 64	ASA 64	135mm: 135-36, 135-20, 126-20	

2. Artificial-light film

Brand Kodak:	Speed	Size	Suitability	Light Source
High-speed Ektachrome Type B (EHB)	ASA 125 or up to ASA 400 with special processing.	35mm: 135-20, 135-36 roll film: 120	Necessary only for photographing moving objects or pieces on models. Increased film speed entails increased graininess and a loss of extreme sharpness.	Tungsten light of 3200 K.
Kodachrome 40 Type A (KPA)	ASA 40 ASA 32	only 35mm: 135-36	Ideal for object photography with artificial light because of excellent color rendition and extreme sharpness. Finest grain of all Kodak slide films.	Photolamps of 3400 K. Tungsten lamps of 3200 K. with Kodak filter No. 82 A
Ektachrome Professional Type B (EPB)	ASA 32 ASA 25	only roll film: 120	Ideal artificial-light film for object photographers using the larger format.	Tungsten lamps of 3200 K. Photolamps of 3400 K. with Kodak filter No. 81 A
Agfa: Agfachrome 50 L Professional	ASA 50	35mm: 135-36 roll film: 120	Professional-quality slide film recommended to those wishing to use both the 35-mm and the larger formats without having to change lamp temperatures or to use filters.	Tungsten lamps of 3100 K. (You can use your 3200 K. lamps after they have been burning for about 30 minutes.)

3. Negative Film

Brand Kodak:	Speed	Size	Suitability	Light Source
Kodacolor II	ASA 80 ASA 25 ASA 20	35mm: 135-20, 135-36 roll film: 120, 127, 620	Standard color negative film, suitable in object photography for enlargements up to 4 inches by 5 inches.	Daylight or flash Photolamps of 3400 K. with Kodak filter No. 80 B Tungsten lamps of 3200 K. with Kodak filter No. 80 A
Ektacolor Professional Type S (6006)	ASA 100	only roll film: 120, 220	Professional-quality film for exposure times faster than 1/10 second, suitable for enlargements up to 8 inches by 10 inches.	Daylight or flash
Ektacolor Professional Type S (5026)	ASA 100	only 35mm: 135-36		
Agfa: Agfacolor CN 17 Universal	ASA 40	35mm: 135-20, 135-36 roll film: 120, 127, 620	General-purpose, unmasked color negative film. Also yields satisfactory black-and-white prints.	Daylight, flash, and artificial light
Agfacolor CNS	ASA 80	35mm: 135-20, 135-36 roll film: 120, 127, 620	Improved grain and sharpness. Renders satisfactory enlargements up to 8 inches by 10 inches.	Daylight or flash

NOTE: This list of color slide and color negative film does not mention all brands available on the market; rather, it reflects the author's personal experience in object photography. The quality of color negative film largely depends on the expertise of the finisher. All color slide film can be used to obtain color prints, and color negative film can yield color slides, but with a loss in color quality and sharpness.

DAYLIGHT

True color rendition depends almost exclusively on the color of the illumination. Only when the illumination is white or nearly white do the colors of an object appear natural. Just as a snow-covered field appears slightly pink in the early-morning sun, orange in the evening, and blue in the shade on a sunny day, any object reflects the color of the illumination together with its own colors. The object photographer should be aware of this to avoid an unpleasant color cast. Using a daylight color film outdoors, therefore, does not automatically guarantee true color rendition. Natural light outdoors is highly unstable, and its color shifts must be taken into consideration.

Direct Sunlight

The color quality of direct sunlight on a clear or slightly hazy day changes from light pink to orange to yellow from early morning to mid-morning, becomes harder and more bluish at midday, and warms up again in the evening. This color shift also depends on the general altitude of the sun, which changes with the seasons. The professional color photographer avoids the hard, bluish light at noon and photographs outdoors during mid-morning and mid-afternoon (see figure C-1). A warm, yellowish cast is more acceptable to the eye than a cold, bluish tone.

Diffused Light

The most suitable diffused light is found in the shade of white walls or on a hazy, slightly overcast day. Its color quality varies, depending on the nature of the sky. Since the warm tones of direct sunlight are missing, a clear, blue sky will add a very strong bluish cast to the colors of an object photographed in the shade. The same is true of a heavily overcast sky, as a large amount of ultraviolet light passes through the clouds, while most of the warmer light is reflected.

To compensate for prevailing bluish light, a skylight filter (for example, Kodak filter No. 1A) or an ultraviolet-light-absorbing filter, which is stronger (for example, Kodak filter No. 2A or 2B), should always be used. These filters absorb part of the cold ultraviolet light and thus warm up the color of the illumination. If you find that the skylight filter does not eliminate the bluish cast completely, try the ultraviolet-light-absorbing filter (see figure C-2a and b).

It should also be noted that the color of indirect illumination is also altered when it is filtered through green leafage. To avoid a blue-green tone in your color slides, do not place your objects in the shade of a tree.

ARTIFICIAL LIGHT

Color photography indoors with artificial light is a safe alternative if you want to be independent of weather conditions and time of day. The stable lighting conditions available with artificial light fully justify the initial expense for lamp stands and light bulbs. I strongly recommend bulbs of at least 500 watts, which generally provide sufficient light to avoid exposures longer than 1/2 second. Longer exposure times usually require additional color-correcting filters, which are listed on the instruction sheet of the film.

When taking color slides in artificial-light conditions, it is necessary to coordinate the film to the color temperature of the light bulbs. The color temperature of a tungsten lamp is either 3200 Kelvin or 3400 Kelvin. (On some brands the temperature is printed on the bulb.) Lamps with 3200 K. are generally called *tungsten lamps,* whereas lamps with 3400 K. are sold as *photofloods.* Quartz-iodine lamps, available in both 3200 K. and 3400 K., have a long life and a stable color temperature, but their harsh, contrasty light makes them less suitable for object photography.

The color temperature of a slide film is printed on the instruction sheet along with information regarding the use of filters when the film and the light source are not color-temperature coordinated. For instance, if you plan to take 35-mm color slides on fine-grain Kodachrome 40, you must use 3400 K. lamps or an 82A filter with 3200 K. lamps. If you are planning to take 2 1/4-inch color slides on Kodak Ektachrome Professional Type B, your lamps must have a color temperature of 3200 K. Each light source has advantages and disadvantages with regard to 35-mm photography. The tungsten lamps (3200 K.) have a longer life and a stabler color temperature but require a filter. The photoflood lamps (3400 K.) have a relatively short life span, but slides may be taken without a filter on Kodachrome 40. If you wish to take 35-mm color slides with 3200 K. tungsten lamps without a filter, you can use Agfachrome Professional Type L after your brand-new bulbs have been burning for about 30 minutes.

The color temperature of photo lamps does not remain constant but decreases with extended use after burning for several hours, resulting in an overall warm, yellowish cast to your slides. To extend the life of the lamps, start out with brand-new bulbs and use them only for the essential picture-taking process. Use an ordinary household lamp while arranging the object and its background.

When photographing indoors during the day, be sure to exclude all daylight by closing the curtains or shutters. Fluorescent light should be switched off. Mixing daylight or fluorescent light with tungsten light will produce unpleasant color distortions.

Photographing indoors in galleries or museums without tungsten light will rarely yield agreeable results with artificial-light film. If permitted, substitute missing daylight with flash and daylight film. If flash is not allowed, colors will generally come out better on daylight film than on artificial-light film. Filters for fluorescent light are also available for either type of film.

C-1. Ceramic form photographed at mid-afternoon on a slightly hazy day with Kodak Ektachrome. The object was separated from its out-of-focus background by selecting an f-stop (f-8) that provided just enough depth of field to render the object sharp. (Artist: Renate Etzler, Germany)

C-2. Macramé necklace photographed outdoors on a pink background with daylight color slide film (Ektachrome). (a.) Diffused light in the shade. The absence of an ultraviolet-light-absorbing filter caused the unpleasant color shift towards blue. The pink background appears purple. (b.) Diffused light in the shade. The bluish cast was eliminated with an ultraviolet-light-absorbing filter. (c) Late-afternoon sun cast a warm, yellow-red light on the piece, shifting the colors, especially the pink background, towards orange.

Bracketing a correct exposure with one overexposure and one underexposure. The necklace was photographed on artificial-light film (Ektachrome Professional Type B roll film) with two 500-watt lamps (3200 K.) and diffusing screens. (d.) f-16/1/30 second (underexposure). (e.) f-16/1/15 second (correct exposure). (f.) f-16/1/8 second (overexposure).
(g.) Detail of the intricate knotting pattern. (h.) A black velvet background emphasizes the luminous colors. (i.) A white background subdues the colors. (Artist: Jean Battles, U.S.A.)

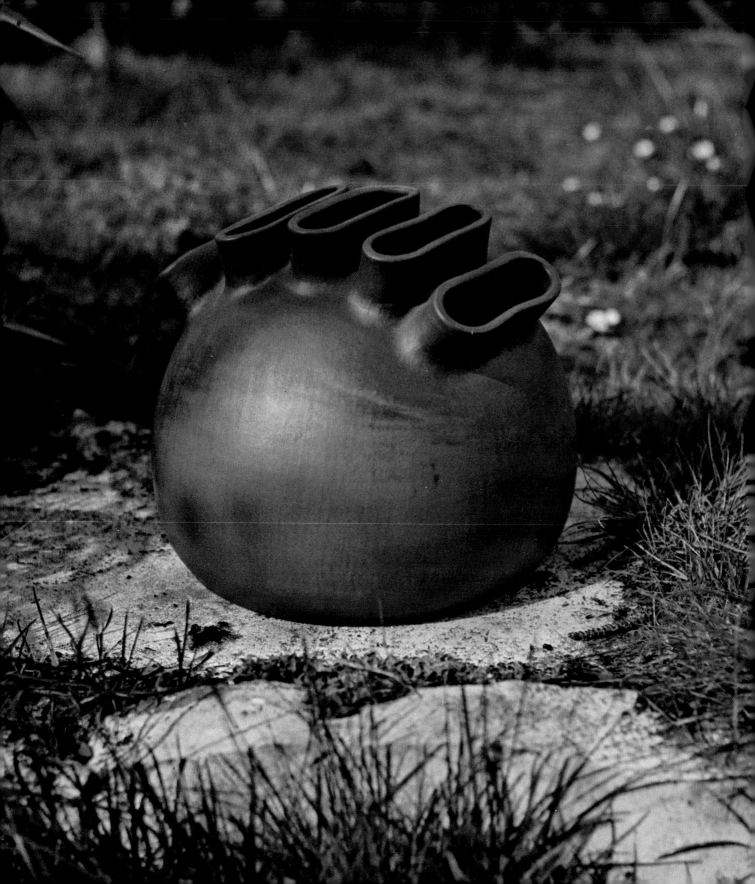

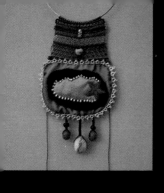
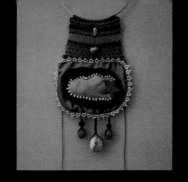
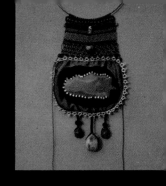

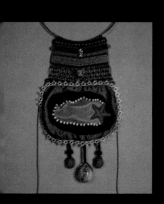
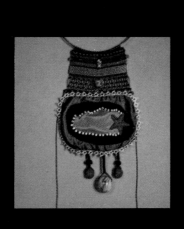
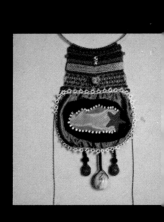

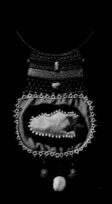

REFLECTED LIGHT

While the quality of the main light source is usually carefully considered, the possibility of light reflected from another colored surface is too often overlooked during the actual picture taking. White light reflected from a colored surface assumes the color of the reflector: when an object is placed next to a red door, for example, the light reflected from the door will add a reddish tone to the object.

You must control the immediate surroundings of your subject thoroughly, indoors as well as outdoors. Trees, grass, colored walls, ceiling, or carpets in the close vicinity are serious problems when taking color slides, as their effects cannot be altered on the finished slide. Background colors do not affect the colors of the object as long as the background cannot be reflected back to the piece.

CONTRAST

Contrast, the range between dark and bright tones in a picture, demands the particular attention of the color photographer, since color film has an even narrower range of contrast than black-and-white film. Among the essential factors determining the overall contrast of a scene are the contrast of the illumination and the contrast between object and background.

Illumination Contrast

The illumination contrast depends on the type of lighting used to photograph an object. Direct light from the sun or a reflector lamp provides a hard, contrasty illumination that increases the contrast between shadows and highlights. Indirect, diffused light in the shade or from reflector lamps covered with diffusing screens reduces this contrast considerably. Whereas a high illumination contrast is sometimes preferable in black-and-white pictures, the color photographer should try to reduce or eliminate the illumination contrast. The strong shadows that are often necessary to bring out the texture and form of an object in a black-and-white picture will generally interfere with the design and disturb the effect of a color piece. The contrast in color photography should be in the colors rather than in strong highlights and shadows. The lighting technique, the position of the lamps, and the type of lighting used should be subordinated to the color and should remain almost imperceptible to the beholder of the final color slide or print.

Object-background Contrast

The narrow contrast range of color film also requires careful adjustment of the contrast between the object and a colored background. The contrast range is best determined by separate spot readings of object and background. These should not exceed a ratio of 1:4, which is equivalent to two f-stops. For excellent results, try to stay within or below a 1:2 ratio, which is equivalent to one or less than one f-stop. If , for instance, an object reads f-11 / 1/30 second and the background reads f-5.6 / 1/30 second, the exposure difference is two f-stops. The contrast ratio is 1:4, meaning that the background calls for four times as much light as the object. A correct exposure would lie between the two readings at f-8 / 1/30 second. This exposure would slightly overexpose the object while underexposing the background.

If the object-background contrast is too high, a less contrasting background should be used in combination with a softer illumination. Highly reflecting background papers or walls as well as light-absorbent materials such as dark velvet usually exceed the general contrast range of object and background and should be avoided or used with the utmost discretion. An exception to this is, of course, the black background. In this case, the color of the background is not a factor and the object alone is measured (see figure C-2h).

EXPOSURE AND BRACKETING

The technique of determining correct exposures is discussed in Chapter 5. The principles and practical advice set forth there can be fully applied to color photography, with the reminder that correct readings are even more critical, due to the narrower exposure latitude of color films. In order to compensate for possible exposure errors, you should always bracket the supposed ideal exposure with at least one overexposure and one underexposure (see figure C-2d, e, and f).

C-3. To bring out the warm, glowing color of this free-blown glass vase, slight backlighting was used, and the object was placed inside a light cage. A sheet of tracing paper provided a seamless, neutral-gray background. (Artist: Rachel Maloney, U.S.A.)

C-4. The juxtaposition of cold blue with warm brown colors and the contrast between large and small intricately woven areas form a center of interest that unifies this detail from the large tapestry shown in figure 2-4. Even illumination of this relatively small area was achieved with four 500-watt reflector lamps (3200° K.). Photographed with Ektachrome Professional Type B roll film at f-16.

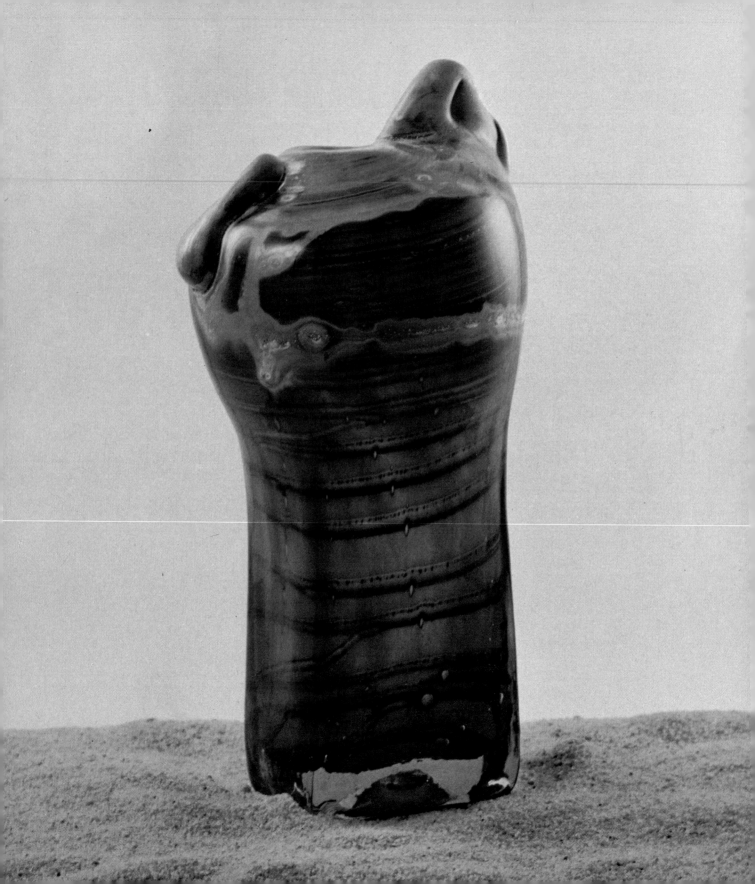

7

Presenting the Object

The quality of an object photograph depends not only on your technical skill and the equipment that you use but also on your approach to the object. While the viewer of a work of art has a fairly total impression of the piece from a multitude of visual perspectives, the photograph is limited to the two dimensions of the film and subject to the sensitivity of the photographer in arranging the object and selecting a point of view. Any slide or photograph, whether in color or black and white, is essentially an abstraction of the real object and its many visual and tactile aspects. The limitations of the two-dimensional photographic medium force the photographer-artist to concentrate on essential and expressive aspects of an art object. By selecting the viewpoint, detail shots, and the background, the artist gains control over the visual impact and by this very control expresses a personal attitude and feeling toward the object.

7-1. (a.) The total view defines the form of the bronze sculpture (17 inches high). (b, c, and d.) The details from different points of view direct attention to aspects that otherwise would be lost in the total picture. The total view utilized diffused illumination through two reflector lamps: one main light on the upper right, balanced by a fill-in light on the left to soften deep shadows. This light setup emphasized the roundness of the sculpture while retaining some of the reflectivity characteristic of the material. For the close-ups, a strong sidelight was used to bring out surface texture, and extension tubes allowed photographing from close distances. Photographed on 35-mm Panatomic-X film. (Artist: Bertram Graf, Germany)

POINTS OF VIEW

Trying to represent an object with just one photograph often becomes a frustrating experience that frequently falls short of the essential concept of your work. Large, complex, or three-dimensional objects are hardly ever recorded sufficiently on one slide or print, as a single perspective allows no further exploration. Although economic reasons often force magazine and book editors to limit the number of supplementary photographs per object, you should always choose as many different points of view, including details, as possible for your personal art portfolio (see figure 7-1a–d).

A camera has only one "eye," the lens, whereas you are accustomed to looking at things through two eyes and to making adjustments for changes in perspective. In order to experience this difference and to visualize the objects the way your camera "sees" them, you should detach the camera temporarily from the tripod and search for the best camera angle or detail cropping while looking through the viewfinder. During this process of intense visualization, you may experience the excitement of rediscovering your art through the medium of photography.

a.

b.

c.

d.

A series of pictures should contain one photograph of the piece in its entirety in order to emphasize proportion, design, and disposition of formal elements rather than detail. If the object can be viewed from more than one side, take more than one total picture. Three-dimensional, square, or rectangular forms should be photographed off-center, as a straight frontal view will give no indication of the object's third dimension (see figures 7-2 and 7-3).

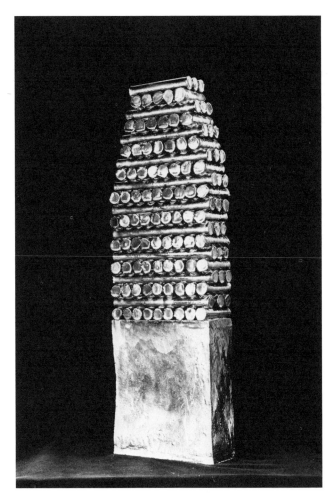

7-2. Sculptural pottery form. In a straight frontal view, the rectangular form of this three-dimensional object cannot be distinguished, and the object appears flat. (Artist: Tony Hepburn, England)

7-3. The same pottery form photographed off-center to represent all three dimensions of the piece while at the same time revealing the layered construction. Photographed on Agfa Professional 25 roll film.

Detail Photographs

Consequent points of view should present detail areas from a closer distance to record surface structure, texture of different materials, and interrelationships of elements of form(see figure 7-4). An area chosen for detail should itself be a unified compositon that can stand on its own as an artistic entity. Detail photographs are particularly crucial for large, textured pieces such as tapestry, macramé, or weaving to provide an impression of the nature of the fibers and their intricate manipulation, aspects that are lost in a total picture (see figures 7-5 and 7-6). Three-dimensional objects such as the sculpture in figure 7-1 may invite a whole series of exploratory photographs that lead the beholder into the piece. With the help of close-up devices, the artist-photographer may experience the fascination of reexploring an art object through the eye of the camera.

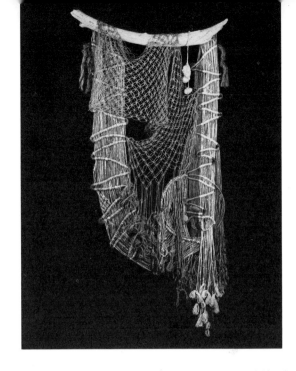

7-5. Straight, frontal, total view of *The Sea,* a knotted, fiber hanging. This large, complex piece demands careful selection of detail views to capture the great variety of compositional elements. (Artist: Barbara Wittenberg, U.S.A.)

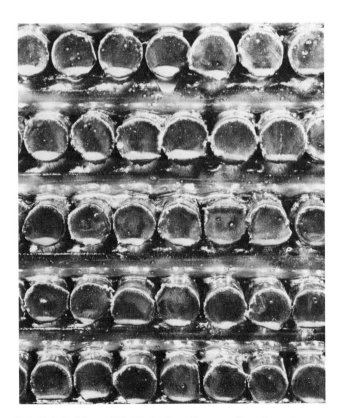

7-4. Detail of figure 7-2. Eliminating all surrounding elements emphasizes the strong, repetitive pattern.

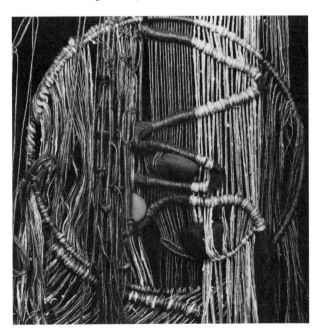

7-6. Detail of figure 7-5. The variety and delicate texture of the fibers employed in this piece can be conveyed only through detail photographs. The circle gives artistic unity to this section (see figure 5-7 for a third view).

Table-top Views

A table-top picture is taken from above the piece with the camera looking straight down. In comparison with a frontal picture, which reveals a more normal and quieter character, a table-top view emphasizes and dramatizes formal aspects of a three-dimensional object. The contrast between the round and oval shapes of the group of vases shown in figure 7-7 becomes apparent only in a table-top view. Whenever a creation lends itself to this extreme perspective, the photographer can benefit from the possibility of showing new and surprising aspects of a piece (see figure 7-8).

It should be noted that this fairly extreme camera position requires a very stable tripod with an invertible center shaft (see figure 2-6). When using lamps, make sure that the tripod does not cast any shadows on the picture area.

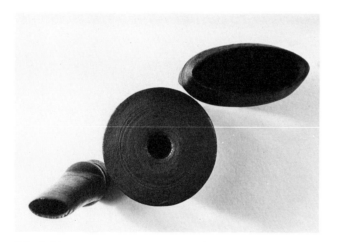

7-7. Striking table-top view of the vases shown in figure 7-11 gives a totally new perspective. Photographed with 35-mm Panatomic-X film.

7-8. Table-top view in a natural setting of the ceramic form shown in figure 4-2. Outdoor table-top views must be taken in diffused light to avoid shadows from the tripod and the camera.

DISTANCE AND CROPPING

The distance of the camera from the object is an important consideration in determining your negative or slide cropping. A great many pictures, particularly slides, lack visual effect because of cluttered backgrounds or ineffective cropping. Always consider your viewfinder to be the final frame of the scene you want to photograph. This applies to color slides in particular, as they do not allow further cropping in the darkroom.

The impression of a piece will be considerably reduced if a slide is taken from too great a distance. The object will seem lost in proportion to the background, and very little detail will be visible (see figures 7-9 and 7-10). If an object is photographed in a crowded workroom, the viewer will be distracted from the subject, and the central emphasis, which should be on your piece, will be missing. Although in black-and-white photography unwanted background caused by positioning the camera too far from the object can be cropped by the darkroom worker, the increased enlargement necessary to print just a small portion of the negative will result in more grain combined with a loss of sharpness, while a large portion of the negative space is wasted. When photographing in a craft studio, remove as many extraneous items from the picture area as possible, and bring the camera close to the object to exclude unwanted background; better yet, use a backdrop.

Pictures taken from too short a distance are cropped too close and suggest crowdedness and a lack of space. This is especially important with slides, as they receive a slight additional cropping from the cardboard or plastic frames.

Examining your previous frames and negatives should tell you whether your cropping has been adequate, too close, or too ample. By considering your viewfinder as the final frame (SLR cameras allow the most precise croppings) and by taking the time to consider this carefully whenever you take a picture, you should be able to crop your slides and prints correctly.

7-9. Inadequate cropping. Although the full piece appears to be correctly cropped — centered with sufficient space on top and bottom — the extreme length of this necklace requires a relatively large photographing distance with a consequent loss of subtle detail in the knotting.

7-10. Adequate cropping. A closer view showing just the essential part of the piece is a preferred cropping, since it records more detail and conveys a better feeling of the intricate work of the piece. Both examples photographed on 35-mm Panatomic-X film. (Artist: Jean Battles, U.S.A.)

PRESENTING GROUPS OF OBJECTS

Many artists, particularly in ceramics or glass, create series of objects in the same technique to explore form, size, surface texture, or color. Showing several of these variations together in one picture is often a more effective presentation than taking separate photographs of each individual piece. Photographing several pieces at once is by no means a time-saving procedure, however, as arranging, grouping, and lighting have to be balanced very carefully to create a feeling of unity in the group while at the same time giving maximum definition to each element (see figure 7-11).

Objects related through material, form, color, or usage can be grouped in an infinite number of variations, depending on the skill and taste of the photographer. To form a rhythmical repetition, several identical objects may be placed at increasing distances from the camera. This will cause growing unsharpness, which can be controlled by expanding the depth of field. Or you can use the unsharpness to indicate the third dimension (see figure 9-12). Identical objects or objects that differ only in color may be grouped in close contact, with or without overlappings, to create patterns through repetition of one element of form. Objects varying in size alone should be grouped together to demonstrate their relative proportions. Repetition can be varied by repeating identical forms in different positions to show several aspects of a piece simultaneously (see figure 7-12).

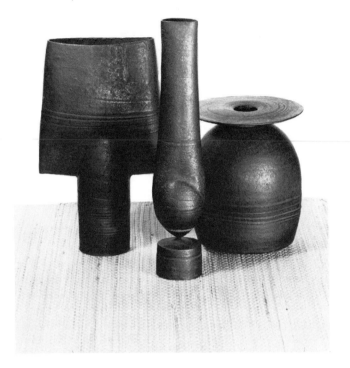

7-11. These three vases show an affinity of material and surface rather than of form. Grouped together, they demonstrate their variation in shape. When arranging objects in close contact, lighting must be carefully adjusted to retain the individual forms. Two sidelights at 45-degree angles combined with Panatomic-X film brought out fine surface detail on these low-contrast objects. A very flat camera angle, together with a 135-mm lens, reduced distortions of size to a minimum. (Artist: Hans Coper, England)

7-12. Clay boots. By placing the second shoe in a different position, a double visual aspect was opened up in one photograph. (Artist: Fongi, Germany)

70

8

Background

In craft photography, the object must always be seen in its relationship to the surrounding background. While the object, of course, is dominant, the background constitutes a vital counterpart, enhancing the visual effect of the object. The basic function of background is to single out an object or group of objects for concentrated observation and appreciation. This demands a definite subordination of background to object. There are many and varying degrees of subordination, from an almost nonexistent, seamless background to a structured wall or a specific location such as a windowsill. In some cases, this relationship can be effectively changed into a vivid and meaningful interplay between object and background; interesting textures in a natural outdoor setting were used to emphasize the organic characteristics of the ceramic form in figure 8-6. However, the background should never dominate to the extent that the viewer first perceives it and then must search for the object.

THE CLASSIC APPROACH

Black, white, gray, and monochromatic backgrounds are the most widely used in art photography and may be considered collectively as the classic approach to background. Especially when shadows are reduced, this type of background tends to focus the viewer's concentration on the object itself, thereby emphasizing subtle shape and surface texture (see figure 8-1).

8-1. Steel and gold brooch. The black background concentrates attention on the subtle interplay of shapes and flowing lines. The brooch was pinned on a soft board and photographed in a vertical position, illumination was provided by two screened reflector lamps placed at either side. Panatomic-X roll film was used. (Artist: Hubertus Skal, Germany)

In black-and-white photography, contrast between the object and its background is essential for definition and separation of outlines. For good contrast, place objects with middle to dark tones in front of a lighter background and objects with lighter tones in front of a darker or black background. The majority of art reproductions tend to follow this basic principle, although, of course, exceptions are possible. Light backgrounds usually have a calming, stabilizing effect on the object, whereas black backgrounds often underline its dramatic qualities. When calculating exposure times for this type of contrasty situation, take a close-up reading of the object alone.

For the color photographer, a monochromatic background becomes a decisive element that either supports or modifies the color effect of the object. As a basic guideline for choosing a suitable background, the widely known principle of color harmony is helpful. According to this principle, two or more colors have a harmonious effect if mixing them would produce a neutral gray. The color wheel shown in figure 8-2 can be used to calculate harmonious combinations; you may find it effective to place a monochromatic object against a complementary background. When working with more than two colors, combinations that form triads or tetrads exhibit a harmonious relationship. For example, a piece containing blue-violet and red-orange may be best presented on a yellow-green background. As detailed information on color theory is not within the scope of this book, I recommend *The Elements of Color* by Johannes Itten for those interested in further study.

8-2. Color wheel. Colors directly opposite to each other are complementary. Harmonious backgrounds may be found for multicolored objects by rotating a triad or tetrad to find the third or fourth harmonious color.

Color theory, however, can only point you in a general direction. Before making the final decision, you should try several backgrounds with your object, using the same illumination that you will use in the photograph. Your sensitivity as an artist should be your ultimate criterion.

Uncolored backgrounds occasionally provide a very effective background setting, particularly if a colored background might destroy a color effect in the piece. Black, gray, and white have different effects on the colors of an object and should be used accordingly.

Black tends to enhance the luminosity and intensity of adjoining colors. Therefore, a black background can be an effective and strong possibility when photographing colorful objects that show a strong contrast of hue within themselves (see figure C-2g).

A neutral-gray background is often suitable for three-dimensional objects with moderate contrast of hue and a tendency towards pastel colors. This is often difficult to achieve with gray background paper, since the gray of the paper often shifts to the complementary color of the object. A more successful approach is to place the object on a tracing-paper background that can be illuminated from behind or below by two or more lamps. In addition to this backlighting, the object must, of course, receive more illumination from the front in order to avoid a silhouette effect, which would render the object too dark (see figure C-3).

A white background is, in most cases, a very poor solution for showing a colored piece. White weakens the luminosity and intensity of the surrounding colors. The extreme contrast between background and object usually leads to either an overexposure of the background or an underexposure of the piece. If a white background is the only possible choice, take a close-up reading excluding the background. The piece will then receive proper exposure, but the background will be overexposed and appear washed-out (see figure C-2i).

Setting up a Seamless Background

A different approach is necessary if you are using a uniform, seamless background with flat or three-dimensional objects. Flat pieces such as wall hangings, tapestries, or macramé are simply hung in front of a suitable background material. A soft board will facilitate pinning sheets of background paper or pieces of fabric in a vertical position.

Three-dimensional objects such as pottery or sculpture call for a more sophisticated approach. When placed against a piece of background material, the edge of this background will almost always be visible as a line behind the object. To avoid this, attach to a soft board a sheet of background paper or fabric that is large enough for it to curve down gently to a horizontal working plane on a table or floor. This eliminates the edge where the horizontal plane of the table meets the vertical plane. When working with dark or black background paper, the curve of the paper must be wide enough to avoid any accumulation of reflected light, which would show as a distinct streak. By moving the object away from the vertical part of the background, there is sufficient room for a gentle swing of the paper, and control over lighting is increased (see figure 8-3).

8-3. Setup for a seamless background. The background material gently swings from the vertical into the horizontal plane, thus eliminating disturbing background lines.

Background Material

A seamless background, whether paper or fabric, must have uniform color. If your objects tend to be very large, a roll of seamless paper would be a worthwhile investment for a standard background (see figure 8-4). It is sold in photo-supply stores in 12-yard rolls, either 107 or 54 inches wide. Most manufacturers offer a wide range of colors and shades of gray as well as black and white. For smaller objects, sheets of mat, nonreflecting paper, which is available in art-supply stores in many colors, is an equally satisfactory alternative.

If you find that your brand of paper still reflects too much light (black paper comes out grayish when the object is properly exposed), you should consider using velvet as a background. Velvet has the lowest possible degree of reflection. Black velvet will guarantee solid-black backgrounds. For gray backgrounds in black-and-white photography, I prefer light beige or gray velvet to gray paper, which often reflects too much light and appears almost white. Velvet also softens shadows more than paper backgrounds. It should be noted that velvet may cause difficulties in color photography because of its low reflectance. Rich, saturated colors tend to absorb too much light and come out too dark on slides if the object is considerably brighter. Lighter, pastel-colored velvet is better, but a careful spot reading of both the object and the background should definitely be taken to make sure that the contrast is not excessive.

8-4. *Double Wings,* a knotted structure in red sisal (6 feet high). A large roll of white seamless paper helped to eliminate all extraneous elements in the artist's studio where the piece was photographed. Lighting was provided by four screened reflector lamps with 500-watt bulbs. Panatomic-X was the ideal film to handle the low-contrast object. (Artist: Jon Wahling, U.S.A.)

Eliminating Shadows

When working with the classic gray or white background in black-and-white photography or any monochromatic background in color photography, the main shadow from your object becomes a strong pictorial factor that you may wish to emphasize or reduce. (On black backgrounds, of course, shadow is no problem.) The main shadow can become a background element by indicating the base of an object, as in figure 9-13, or by repeating the shape of a form in a different fashion. Usually, however, you will wish to reduce shadows, particularly when using several lamps, each casting a distinguishable shadow. There are several methods to eliminate or reduce overlapping and crossing shadows on light backgrounds, which vary according to the basic structure of the object.

Suspended Objects

To completely eliminate shadows cast by a hanging piece, simply remove the background far enough for the shadow to fall outside the cropping. This can be achieved by placing lamps at an angle of approximately 45 degrees on either side of the piece. The shadows created by the lamps will then fall outside the picture area.

Flat and Three-dimensional Objects

Flat pieces present relatively few shadow problems as long as they receive a fairly frontal lighting that reduces shadow lengths to a minimum. Three-dimensional objects, however, can be seriously affected by heavy or misplaced shadows. Soft, diffused light is almost always called for when you wish to eliminate shadows. Perhaps the easiest way is simply to photograph outdoors in the diffused light available on an overcast day or in the shade of a wall. This type of lighting can be created indoors by directing the lamps away from the object itself and reflecting the light from a white wall or ceiling. The light rays will be totally diffused and will not create distinguishable shadows. This type of illumination, which is known as *bounced lighting,* is much weaker than direct lighting and calls for longer exposure times. Bounced lighting is not suitable for emphasizing texture or shape.

In most cases, shadows are softened by placing diffusing screens of tracing paper in front of the light sources (see figure 4-6) or by using a light cage (see figure 4-7). A velvet background will also soften shadow outlines considerably.

Although distracting and overlapping shadows must be eliminated, you may often wish to retain one main shadow to indicate the base of an object or to emphasize its form. In this case, simply move one lamp (with a diffusing screen) closer to the object to create one stronger shadow. Try several combinations of your lamps and view the effect through the viewfinder before deciding on the final arrangement. You may even want to take several different pictures in different lighting situations and then decide on the final print when you examine the contact strips.

Indicating Relative Size

One consequence of the classic seamless background is that it provides no indication of the size of an object placed on it. This may become a serious drawback with extremely large or small objects. While it may not always be possible or advisable to provide direct size indicators within the picture, there are a number of ways to do so if you feel that the object's size should be obvious at first glance or if this is required by an art jury.

One of the most widely used indicators is a human or animal figure (the cat is an honored favorite). A person placed next to a taller-than-life statue, for instance, will immediately convey its true size to the beholder. Small pieces may gain a reliable scale from the hand or fingers holding them. Another possibility is to include natural objects that do not vary greatly in size, such as pebbles, sand, leaves, shells, and so forth, provided that they harmonize with the object (see figure 8-5). Used sparingly and with discretion to avoid distracting from the object itself, they will help the viewer to identify and experience the actual dimension of your object spontaneously without referring to separate measurements. (See below for information on more emphatic natural and human backgrounds.)

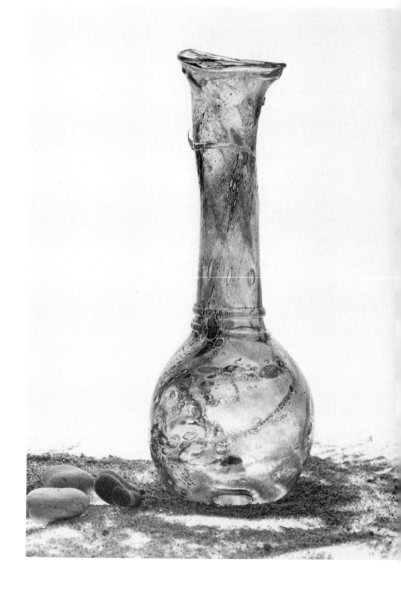

8-5. Delicate glass vase. This piece was photographed inside a light cage on a seamless, tracing-paper background. Slight backlighting brought out the subtle detail in the glass. Sand and small pebbles were used to indicate the base and the relative size of the object. (Artist: Pavel Molnar, Czechoslovakia)

THE STRUCTURED OR NATURAL BACKGROUND

Structured backgrounds offer a wide range of creative approaches to presenting an object, in black-and-white as well as in color photography. In the former, a certain surface texture or the pattern of light and dark elements will often suggest an effective background. In the latter, shades of one color or a more uniform texture such as wood or fine sand are very suitable background possibilities. A bright, multicolored background, of course, should be avoided, as it would distract from the object.

New, interesting textures and background-object combinations are usually very enjoyable alternatives to the seamless backgrounds so frequently employed. You may start looking for background material at home and find coarsely woven materials, rough jute rugs, bast mats, or even a friend's hair (see figure 8-8). Outdoors, the regular pattern of a brick wall or the rough surface of light concrete or dark asphalt may interest you. You might also be attracted by a natural setting on the beach, a river bed full of pebbles, or the mysterious atmosphere of a forest with its mosses, fungi, and tree bark. Each of your objects may suggest a new setting to emphasize a specific quality of your piece and bring it to life without detracting from its essential qualities of form, color, surface texture, or structure (see figure 8-6).

When working outside in a natural setting, you should keep your camera on a tripod even if you think there is enough light for a fast exposure time. (Your camera should always be on a tripod, whether indoors or out!) Pick a slightly overcast sky to benefit from the soft, diffused light. With color film, a skylight filter should be used to protect your film against the ultraviolet rays that are present in natural diffused light. Take along one or two cardboard reflectors to lighten up shadow areas in the object.

Larger objects can be separated from their natural backgrounds effectively by throwing the background slightly out of focus (see figure C-1). This may be particularly necessary if distracting elements in the background area cannot be removed. Simply select a wider lens opening (larger f-stop) to decrease your depth of field. In general, the larger the object, the larger the f-stop can be. Take a series of pictures, varying the f-stop and compensating the exposure time. With small objects or a camera distance of less than 3 feet, use a small f-stop (f-16 or f-11), as your depth of field at this distance is already so narrow that part of the background will be out of focus anyway.

8-6. Small ceramic form. The organic nature of the piece suggested a natural setting, which was found in a nearby park, where the forms of nature would repeat those of the artist. A cardboard reflector helped to brighten shadows around the base of the piece. The relatively high contrast of the scene was met by selecting a medium-speed film. (Artist: Elisabeth Schaffer, Germany)

THE HUMAN FIGURE

The human figure is one of the most fascinating but difficult backgrounds. Some objects, such as knitted or crocheted articles of clothing or body ornaments, may appear estranged and lifeless if photographed against a plain background, and the most natural and obvious solution is the human body. However, many artists may feel that a live model would distract from their art. This need not be the case, of course, as a model can give an object vitality and purposefulness. A downward or sideward glance will do much to move the attention away from the model to the object. Don't be afraid to show a model if your artwork calls for it; don't try to avoid the issue by using store dummies or cropping the head of a live model from the photograph. Nothing could be more deadening. Headless people are hardly suitable backgrounds for your art!

Your model should be treated in the same way as any "object" in terms of photography. That is, make sure that the model is not situated in a cluttered background and that cropping is adequate but not overzealous, removing vital parts of the body. Light is read from the model rather than from the entire scene. The best film for this type of moving "object" is a medium- or fast-speed film that allows exposure times of 1/60 second or faster at a sufficient depth of field.

An interesting departure from the traditional use of a model is possible in photographing jewelry. While jewelry can, of course, be photographed as it is to be worn, the exotic quality of some jewelry may often be emphasized by photographing it in unusual settings with abstracted sections of the body as backgrounds. The bracelet in figure 8-7 becomes highly dramatic when photographed on a fist rather than a wrist. Human hair makes a flowing, rhythmic background to frame the face in the brooch shown in figure 8-8. The creative possibilities are endless, as the human body has many textures and forms and is thus an intriguing background for experimental photography of small objects.

8-7. Bracelet executed in steel, lapis lazuli, and gold. The visual impact of this bold and dramatic setup was emphasized by the black-velvet background that also covered the model's wrist. Lighting was provided by a single reflector lamp and a diffusing screen to avoid double shadows. Correct exposure was determined by a reflected-light reading of the hand alone. Photographed with extension tubes on 35-mm Agfa 100 film. (Artist: Hubertus Skal, Germany)

8-8. Cast-bronze face on Plexiglas in a silver frame, designed to be worn as a necklace. Human hair provides a richly textured background. The model was seated with her back to a table, which supported her hair for this table-top picture. Two screened reflector lamps illuminated the scene from either side. Photographed with extension tubes and a 135-mm lens on 35-mm Ilford Pan film. (Artist: Peter Jacobi, Germany)

9

Special Problems

Every art object poses different problems of shape, size, surface texture, and color, which have to be solved individually by the photographer. However, many of these difficulties are problems of technique and experience, which can obstruct the creative photographer and cause considerable disappointment until they are mastered. Specific information on methods for working with a certain type of object should help you to avoid common mistakes. The problems discussed below were organized according to different physical characteristics of objects rather than craft areas in order not to repeat technical information. Reference is made to the particular crafts involved within each of the following categories:

 flat objects
 three-dimensional objects
 suspended objects
 shiny and reflective objects
 large and small objects
 contrasty objects

Often an object will fit into more than one category — for instance, a large, three-dimensional, suspended object. In a case like this, the information from each category will be relevant for the photographer. Table 3 provides a convenient checklist of the photographic steps necessary to achieve a good-quality object photograph.

FLAT OBJECTS
Flat objects — paintings, drawings, tapestries, weaving, macramé — are best photographed in a vertical position on a wall or fastened to a soft board. Only when photographing on a background that must remain horizontal, such as sand, should the more difficult table-top position (figure 2-6) be chosen. With both camera positions, there are two equally important factors to be considered: the back of the camera (the film) must be parallel to the picture area, and the picture area must receive even illumination (see figure 9-1).

TABLE 3

Checklist for the Object Photographer.

The following checklist, summing up the vital steps in taking object photographs, was compiled to be used as a quick reference during the actual picture taking.

9-1. Even illumination provided by four lamps and absolute parallelism of the camera to the object were necessary to reproduce this watercolor accurately. (Artist: Karl Ludwig Mordstein, Germany)

1. Film loaded

2. Rewind button turns when film is moved forward

3. Proper film speed set

4. Camera mounted firmly on tripod

5. Cable release screwed in

6. Back of camera parallel to flat object

7. Entire piece/detail appears in viewfinder

8. Piece cropped correctly

9. Camera focused

10. Lighting controlled (even distribution for flat objects!)

11. Strong light reflexes avoided

12. Light reflected from object measured: measuring area shows average distribution of light and dark areas

13. Small f-stop selected (f-11 or f-16)

14. Exposure time set

15. Position of camera and object rechecked for alignment, cropping, and sharp focusing (also after every rewind)

16. Cable release pushed down slowly to take first picture

17. Identical picture bracketed with next slower time

18. Identical picture bracketed with next faster time

19. For detail picture: light reflected from detail area measured for control

20. Exposure time readjusted if necessary

21. Parallelism of camera back with detail area controlled

22. First picture of detail area taken

23. Identical picture bracketed with next slower time

24. Identical picture bracketed with next faster time

Parallelism of Camera and Object

Parallelism of camera back and picture area is of utmost importance when you photograph flat objects. Any deviation from this will distort the object, as parallel lines tend to converge. A rectangle, for example, will become a trapezoid if the camera is placed higher, lower, or sideways in relation to the center of the piece (figure 9-2).

Another result of not having the camera back parallel to the object is partial unsharpness. Some of the picture area will appear sharp, while blurriness will increase towards one side because the depth of field, which always runs parallel to the camera back, will not cover the entire picture area. The areas outside the depth of field will then appear unsharp. Particular care must be taken when you photograph details from a short distance, as depth of field is very limited. Any slight deviation from the parallel will cause unsharpness in parts of the picture area (see figures 9-3, 9-4, and 9-5).

Partial unsharpness and distortion of parallel lines are common mistakes in flat-object photography that could be avoided completely if you always make sure that the back of the camera is exactly parallel to the object. I use a camera level that fits into the flash attachment of the camera to control the vertical position of the camera, and a regular mason's level to check the vertical position of the piece. Don't trust walls!

a.

b.

9-2. Distortion of parallel lines caused by (a.) looking upwards and (b.) looking sideways with the camera.

9-3. Correct recording of a detail from figure 9-1. The entire picture area is sharp, as the camera back was absolutely parallel to the surface of the painting.

9-4. Blurriness in the top half of the picture area is caused by a depth-of-field shift due to a deviation from camera-object parallelism.

9-5. Depth of field no longer covers the entire length of a vertical flat object when the camera is tilted. For complete sharpness, the camera must be parallel to the object.

Even Illumination

Even distribution of light over the entire picture area is essential in order to preserve the impression of flatness and to render detail visible over the entire piece. Even illumination of an area exceeding 8 inches by 10 inches can be achieved only with a minimum of four lamps of equal light output, such as 500-watt lamps, placed at the same distance from the piece. The four lamps should point into the four quarters of the picture area (see figure 9-6). With reflecting objects such as oil canvases or wood inlays, the angle of illumination must be 45 degrees to avoid reflections and glare. Any glass panes in front of pictures must, of course, be removed before photographing. If this is not possible (in a museum, for example), polarizing filters must be used on both the camera lens and the light source.

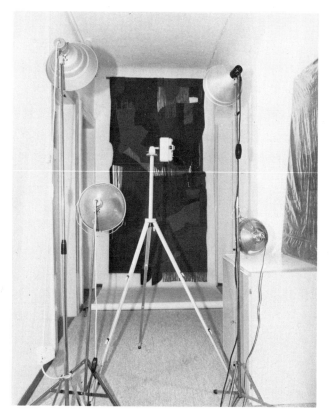

9-6. Light setup for equal illumination of a large picture area. The tapestry is shown full-length in figure 2-4, and a color detail is shown in figure C-4.

Even illumination is a particularly critical prerequisite for even color in color photography. When using monochromatic backgrounds, for instance, the slightest change in light intensity will become visible in a shift of color towards a lighter or darker tone. Since it is extremely difficult to control even distribution of light over a picture area by the eye alone, I recommend using an exposure meter. A hand-held meter is placed at the five points indicated in figure 9-7, and the incident light is read while the meter is facing the camera (see figure 5-10). With a built-in meter, usually not equipped for an incident-light reading, simply take five spot readings of a uniform background or a neutral-gray card before the piece is hung. All of the readings must be identical. The light intensity is adjusted by moving the lamps closer to increase or further away to decrease the intensity of illumination.

When strongly textured surfaces in weaving, macramé, or knitting are to be photographed, the standard light setup may be modified by providing additional sidelight from one or, better, two lamps. The minute shadows cast by these additional lamps will emphasize texture detail. Care must be taken, however, to balance and compensate for the additional light intensity created by the sidelight on the near side by decreasing the distance of the lamps on the opposite side. Texture detail photographed from closer distances will be astonishingly sharp, and subtle surface structure will become apparent when photographed with additional sidelight (see figure 9-8).

Outdoors, both direct sunlight or indirect light in the shade will provide even illumination for small or large flat pieces. Diffused light is generally the best choice; only when you wish to emphasize a moderate surface texture should you use direct sunlight. Flat objects such as weavings, macramé, or collages should be fastened to soft boards, which can then be tilted and swayed into the right position. It is best to photograph in the morning or afternoon when the sun's rays are not quite so steep. Surface texture is emphasized by allowing the light to fall sideways on the picture area; it will cast minute shadows that bring out detail.

9-7. Controlling even illumination by reading exposures at five points of a rectangular area.

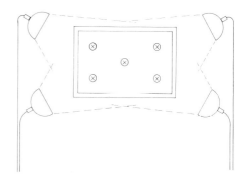

9-8. A strong sidelight brought out the relief structure on this 20-by-24-inch embossed leather object. (Photograph: Kabus, Germany; Artist: Luise Martina-Martin, Germany)

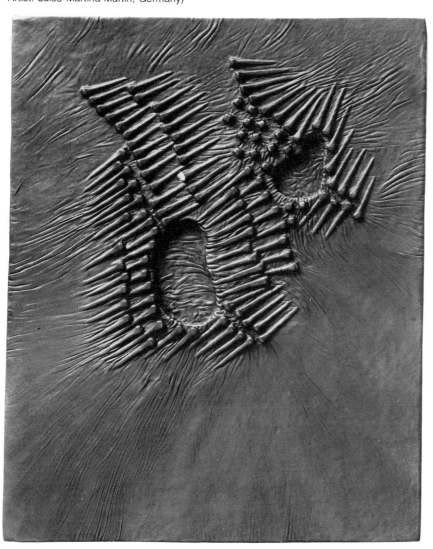

THREE-DIMENSIONAL OBJECTS

The photography of free-form or functional objects made from clay, metal, wood, stone, plastic, or fibers poses the essential problem of retaining spatial qualities in a flat print. Direction of light and shadow, depth of field, base, background, and perspective are all important space indicators that help to induce the spontaneous reconstruction of the original three-dimensional form on the part of the viewer.

Light and Shadow

Shadow is an integral part of a three-dimensional object; controlling light and shadow in a photograph is your principal means of creating the illusion of space. The term "shadow" in photography does not imply something black, but rather an area that is considerably less bright than the lit areas of the picture yet still shows detail. Solid-black shadow areas are acceptable only for highly dramatic effects. On the other hand, trying to eliminate shadow completely will result in a flat picture.

The lighting of three-dimensional objects usually calls for one to three lamps. In general, one lamp dominates, casting the main shadow, while a second lamp (or reflector board) lightens the darkest area of the object to retain detail. A third lamp may be used to control the background, as in figure 9-9. (With a black background, of course, this third lamp is not necessary.) These additional lights should not cast extra shadows around the object, and their light intensity must be subordinated to the main light. In order to decrease the intensity of illumination, simply increase the distance between lamp and object: doubling the distance, for example, reduces the intensity to one fourth. Special characteristics of form do call for individual solutions; the details shown in figures 9-10 and 9-11 required sidelights to bring out the surface texture.

When you are working outdoors, it is best to photograph three-dimensional objects in diffused light. Direct sunlight is much less suitable, as it causes deep shadows that will obscure or even eliminate fine detail. This may be remedied to some extent by using reflector boards to provide additional fill-in light for the shadows. It is, however, much easier simply to move into the shade.

9-9. Clay helmet. Illumination was provided by three screened reflector lamps with 500-watt bulbs, a main light from above right, a fill-in light from lower left, and a third lamp hidden behind the base to provide a sharp contour of the piece. (Artist: Mo Jupp, England)

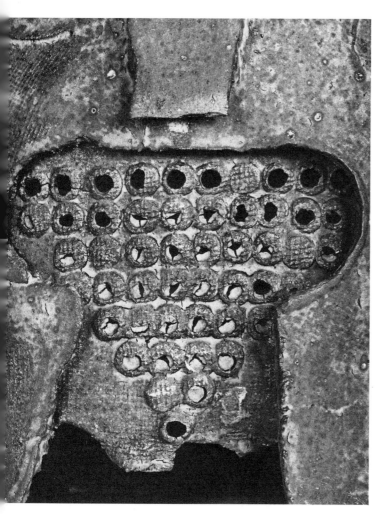

9-10. Detail of figure 9-9 shows an essential aspect of the piece that could not be shown adequately in the total view. Moderate sidelight brought out the particular nature of the glaze. Photographed with Panatomic-X film.

9-11. Detail of figure 8-4. Surface texture was emphasized with strong additional sidelight. Photographed with Panatomic-X film.

Depth of Field

Another good indicator of the third dimension is depth of field, through which increased distance from the camera can be shown by growing unsharpness. Depth of field should be controlled with care, as the object itself must remain sharp or show only a slight loss of sharpness in areas of less importance. Usually an out-of-focus background is enough to create the impression of space.

Repeating similar objects with increasing unsharpness is an alternative use of depth of field. In figure 9-12, the form is clearly represented by one completely sharp object within the camera's depth of field, while a less sharp object indicates the third dimension.

Base, Background, and Perspective

Although a certain abstraction and isolation of the object from its surroundings is necessary to enable the viewer to concentrate on the object itself, complete elimination of the surrounding environment may destroy the spatial quality of three-dimensional objects.

A suggestion of an environment can be created by indicating the base, which may be a pedestal or any horizontal area. This is particularly necessary with a light or dark seamless background, which does not include a space indicator. A strong, single shadow of an object cast by one dominant lamp is often an effective means of adding gravity and depth to a piece that might otherwise appear to float about in an undefined space without reference points for the viewer (see figure 9-13). Another possibility when working with a seamless background is to add sand or pebbles around the base of the object, as in figure 8-5.

Converging lines on the horizontal plane create perspective and do much to emphasize the third dimension. Converging lines may be found on a floor covered with stone flags or a narrow base whose edges appear in the final picture. Compare figures 9-14 and 9-15; the small, white base creates depth and locates the object in a definite space.

9-12. Solid Bohemian-glass forms (14 inches high). The third dimension was indicated by growing unsharpness caused by diminishing the depth of field. The camera was focused on the first object; an f-8 provided sufficient depth of field to render just the first object sharp.

9-13. Ceramic bowl (11 inches in diameter). One main light from the right cast a clearly defined, strong shadow that echoed the roundness of the form and indicated its base. A subordinate lamp from the left prevented that side of the object from becoming too dark. (Artist: Gwyn Hanssen, Australia)

9-14. Ceramic helmet. Converging lines of the rectangular base indicate the spatial surroundings. The low object contrast was best captured by Panatomic-X film. (Artist: Mo Jupp, England)

9-15. The same helmet. Eliminating the base by covering it with black cloth removed the concrete space indicators, and the object seems to float in a black void.

Distortion

One critical factor that is often neglected is the angle of the camera. In general, when photographing three-dimensional objects, the camera should not be tilted but kept parallel to the object to avoid major distortions of perspective and proportion (see below). The greater the deviation from this parallel (in other words, the more you look down or up with your camera), the greater the distortions become. Whenever an angle is necessary, as in photographing an open form, choose a flat angle in order to indicate the opening while keeping the degree of distortion as small as possible.

Objects with a round shape generally suffer less distortion when photographed from a higher or lower point of view. However, as with all objects, the vertical lines tend to converge more the further the back of your camera is tilted from the parallel position, thus causing distortion of perspective. The proportional size is also distorted, since whatever is closer to the camera lens will appear larger in the final picture. Photographing a vase from above, for example, will cause the top to appear relatively larger than the base, thus creating the impression of top-heaviness (see figure 9-16).

A telephoto lens (100-mm to 135-mm focal length) will help to reduce distortions when you are photographing from a higher or lower point of view. The darkroom worker can also correct distortions in prints to a certain extent by tilting the enlarger easel in the opposite direction. Slides, however, cannot be corrected.

9-16. The vase shown in figure 8-5 photographed from an extremely high camera angle. The opening of the vase is proportionally too large for the body, and the base is unsharp due to diminished depth of field.

SUSPENDED OBJECTS

Free-hanging, suspended objects can become quite a test of the photographer's patience if they are not secured to prevent moving and swaying. A bit of "invisible" nylon string tied at more than two points will usually do the trick. Whether indoors or out, the camera should be on a tripod and loaded with a medium- or high-speed black-and-white film; for color slides, choose high-speed Ektachrome. These films allow exposure times of 1/125 second or faster at a reasonable lens aperture that guarantees sufficient depth of field (see figure 9-17).

If you want to photograph outdoors, do not pick a windy day for suspended hangings or pieces with free-hanging parts, such as weavings with long fringes. Even though fast shutter speeds may prevent blurriness due to movement, a section that should be vertical is very likely to be blown to the left or right, and any aberration from the vertical will appear unnatural in the final picture. You want to photograph the object, not the wind!

9-17. Suspended fiber structure. Photographed on medium-speed film that allowed an exposure time of 1/125 second at f-11. Two 500-watt bulbs, the main one from upper right and a fill-in from lower left, provided the lighting. (Artist: Jon Wahling, U.S.A.)

SHINY OBJECTS

Depending on material and quality, some objects have surfaces that reflect light and surroundings in varying degrees, causing considerable problems to the photographer who is not prepared to look for and cope with them. Polished silver or a surface containing silver acts as a mirror and reflects its environment strongly, especially when the surface is round or curved. Next in reflectance come glass, particularly clear glass, polished metal, and some of the very shiny pottery glazes. Among the most disturbing reflexes are those that can clearly be distinguished, such as a light bulb, the camera itself, or even the consternated face of the photographer! Naturally, mirror images of this sort should be avoided, as they distract the attention of the viewer, but you should never go so far as to eliminate all reflections completely. At the right place, a reflex highlights and adds life to a piece. A bright, shiny piece is unfairly represented if it looks dull and mat.

The first step in controlling reflections is to move the light sources around so that the reflexes appear where you want them. Adjust each lamp individually. The further away a lamp is from the object, the smaller its consequent reflection will be.

If you find that your light source is still too clearly defined and discernible, cover it with tracing paper, as demonstrated in figure 4-4. The tracing paper acts as a screen, diffusing the light while at the same time disguising the light source. Instead of a clearly visible lamp, your light source will be reflected in the object as a dim, hazy blot. You can simply place a sheet of tracing paper around a small object, thus blocking a direct reflex of the light source entirely. When working with shiny objects, it is advisable always to have a ready supply of tracing paper on hand.

The light cage described in Chapter 7 is the ultimate answer to highly reflective objects in which everything in the vicinity appears as an ugly line or spot. The light cage will also eliminate reflexes from the light sources. By placing lamps on all sides of the cage and from below and above, very even lighting can be achieved, which is particularly successful with color pictures. The effectiveness of this device is demonstrated by comparing figures 9-18 and 9-19. (The setup is shown in figure 9-20.) It should be noted, however, that black-and-white contrast as well as surface texture is subdued in this lighting setup (see figures 4-5 and 4-6).

If photographed outdoors, shiny objects should be placed in diffused light or in a light cage in the shade. The top of the cage may be left open to admit more light, as the only reflection would be the sky. Color photographers should use a skylight or ultraviolet filter.

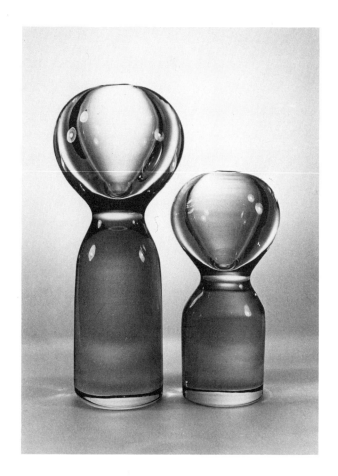

9-18. Photographed outside the light cage, these Bohemian-glass forms reflected the lights as clearly recognizable images.

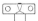

9-20. Lighting setup for Figure 9-19. The objects in the light cage were illuminated from all sides including below. Backlighting emphasized the contours.

9-19. The same glass forms. Reflections were eliminated by photographing inside a light cage that was completely lined with tracing paper, leaving only a small opening for the camera. A more dynamic presentation of the same objects is shown in figure 9-12.

LARGE AND SMALL OBJECTS

Tapestry weaving and jewelry making are just two of the crafts in which the artist often creates objects that are outside the range of sizes generally considered normal. When photographing very large or very small objects, some of the problems already discussed increase in importance, and new ones arise.

Large Objects

The term "large" is, of course, relative, but with respect to photographic problems, difficulties usually arise with pieces larger than approximately 4 feet by 5 feet. A tapestry, for example, that covers almost the total wall space from floor to ceiling actually poses the same problems as any flat object: it must be evenly illuminated, and the back of the camera must be absolutely parallel to the object to avoid distortions. It is just somewhat more difficult to adjust your lamps and camera accordingly when confronted with such huge objects. You may find it necessary to use more than four lamps to achieve even illumination. Whenever possible, take advantage of any available light you may have. The tapestry in figure 9-21 was photographed under available-light conditions with one hand-held 500-watt bulb used as a sidelight to bring out surface texture. This mixing of light sources is, of course, only acceptable for black-and-white photography.

Your camera must face the center of the object. If you are looking upward slightly, the back of your camera is no longer parallel to the piece, and vertical parallel lines begin to converge (see figure 9-2a). If your tripod does not extend high enough while remaining rock-steady, you will have to use a clamp-on or screw-on table tripod, which attaches to a large stepladder. Do not stand on the stepladder when taking the picture, as this can easily cause vibrations. To activate the shutter after the camera is adjusted, use a long cable release or your 10-second self-timer. What is true for large, flat objects also applies to a lesser degree to tall, three-dimensional constructions. Try to keep your camera as parallel to the object as possible.

The artist who often photographs very large objects may find that a wide-angle lens is a worthwhile investment. A wide-angle lens, such as the 35-mm lens, allows you to photograph a large object from a relatively short distance, which is extremely beneficial when photographing inside a studio or gallery (see figure 9-21). The increased depth of field of the wide-angle lens makes it especially appropriate for very deep, three-dimensional structures. Extreme distortion is avoided by keeping the back of the camera in a vertical position.

Particularly with large objects, you should never forget to take at least one detail picture. Intricate detail, surface texture, and nuances of material and technique are bound to be lost in a little 35-mm negative, especially as the size of the object may force you to move 10 to 30 feet away to obtain a total view. Detail photographs also give you the opportunity to direct the observer's attention to areas of particular interest from your own artistic point of view (see figure C-4).

9-21. *Transylvania*, a very large fiber construction (14 feet high). It was photographed inside a museum with a wide-angle lens. Medium-speed film was used to capture the high contrast. (Artists: Peter and Ritzi Jacobi, Germany)

Small Objects

Objects smaller than approximately 5 inches by 5 inches pose one decisive problem: it is difficult to get close enough to the object to fill the picture frame. The 35-mm SLR camera usually does not permit a distance of much less than 2 1/2 feet; the viewfinder camera reaches its limits at about 4 feet. Thus, a ring photographed from this distance will be recorded only on a small section of the negative. A print made from such a negative must then be blown up to such an extent that loss of detail and sharpness due to the increased grain is inevitable.

Close-up Devices

Close-up devices that allow you to work at shorter than normal distances are available for almost any type of camera. The viewfinder camera without interchangeable lenses usually will accept a specially corrected close-up lens, which is mounted onto the existing lens like a filter. However, to compensate for the parallax difference (see figure 2-1) and the increase in exposure time and to control exact focusing calls for quite some experience before satisfactory results can be achieved.

The 35-mm SLR camera with its interchangeable lens system is uniquely fit to solve all these problems with little additional effort on your part. There is no parallax difference, of course, as you are in fact looking through the lens of the camera, and the exposure-time increase is automatically considered by the through-the-lens meter.

Four possibilities are open to owners of SLR cameras. As with a viewfinder camera, you can add a close-up lens in front of your standard lens. Another inexpensive possibility is a set of extension tubes, usually available in three different lengths, which are mounted between lens and camera body (see Chapter 2). Increasing the distance between a given lens and the camera body reduces the distance between camera and object (see figure 9-22). A third but more expensive solution is an extension bellows with a specially corrected close-up lens (usually 100 mm). This is mounted on the camera instead of the standard lens. Whereas the extension tubes allow only a limited number of combinations from among the three different lengths, the extension bellows enables you to select exactly the distance you want, thus increasing your versatility. Finally, an entirely new lens, the macro lens, may be used instead of the standard lens for high-quality close-up reproductions. For occasional close-up photography, the less expensive extension tubes or close-up lenses are sufficient, but if your art field is jewelry, you certainly should consider one of the higher-quality outfits.

Light Reading

The SLR camera with a built-in exposure meter will automatically consider the necessary increase in exposure when using close-up devices. The difficulty in obtaining a correct exposure in close-up photography lies in the smallness of the object from which the reading usually must be taken. SLR cameras with a spot meter system or hand-held meters with a spot reading attachment are clearly an advantage here. If your camera or hand-held meter does not have a spot reading system in addition to the average system, you will have to use a gray card (produced by Kodak) for contrasty settings such as a ring on a black-velvet background. The gray card is placed over the entire picture area to obtain a correct reading. Bracket the exposure with two underexposures and two overexposures to allow for possible mistakes.

Depth of Field

At this close distance, the depth of field even with a small f-stop is only minimal, roughly ½ to ¼ inch. Always choose the smallest possible f-stop (f-16 or f-22) on your camera, while varying the exposure time to obtain a correct exposure.

9-22. Close-up photograph taken with extension tubes on a 35-mm camera. The ring was placed on a round mirror to indicate the curve of the band. The light reading was taken off a gray card. (Artist: Franz Dreyer, Germany)

Vibration

Any tremor or vibration during the picture taking is magnified on the film and will result in unsharp photographs. To counteract all vibrations, it is absolutely necessary to use a rock-steady tripod and a cable release. This is especially crucial in close-up photography, where detail is of the utmost importance and you are working with long exposure times and minimal depth of field.

Most SLR cameras suffer internal vibrations at the time of exposure due to the upward swing of the mirror and the shutter movement, which sometimes makes it necessary to expose without using the shutter at all. To do this, modify the lighting to obtain an exposure time of several seconds (for example, f-16 / 4 seconds). For calculation of extralong exposure times without a suitable light meter, check figure 5-11. Move the exposure indicator to B, and hold a dark cardboard in front of the lens while pushing the cable release. Pull away the cardboard, thus "opening" the lens. Count four seconds and release the shutter, thus closing the lens. Bracket this exposure. Any vibration caused by the mirror and the opening of the shutter will have subsided before you "open" the lens by pulling away the dark cardboard. This procedure is best carried out with a slow film. The mirrors of some SLR cameras can be locked into their upward positions during the exposure, thus eliminating internal vibrations.

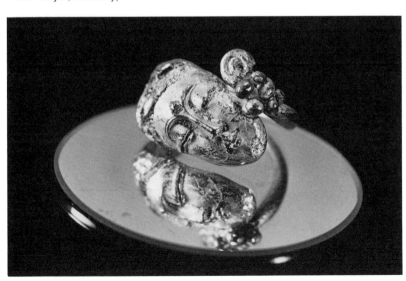

CONTRASTY OBJECTS

A great many objects, particularly in the fiber arts, may show a much greater contrast than black-and-white film and enlarging paper can handle. As a consequence, the darker areas of a piece will appear solid black, while the lighter sections will be washed out and will not record any fine details. Only the middle tones will be recorded satisfactorily. It is not difficult, however, for the object photographer striving for quality to avoid this frequent mistake.

The first step is to determine the actual contrast range. Place the object in its actual photographic setting with what you think is adequate illumination. When comparing the darkest and lightest areas in your piece, do not trust your eyes but take two separate spot readings with your exposure meter. For normal photographic procedures, the exposure readings should not differ by more than two f-stops. In fact, a difference of about one f-stop is ideal for recording both light and dark areas. Exposure readings of more than two f-stops definitely call for reducing contrast. Contrast may be reduced during each stage of the photographic process — lighting, film selection, film development, and printing (see figures 9-23 and 9-24).

9-23. Detail of a contrasty hanging woven of handspun, natural fibers. Photographed with Plus-X film and developed normally, only the middle tones were recorded adequately; the dark areas turned solid black, while the white areas washed out, showing no detail definition.

98

Reducing Lighting Contrast

Contrast may be controlled to a great extent by carefully checking your lighting situation. With some objects, particularly three-dimensional ones that do not show much contrast in themselves, overcontrast may become a simple problem of illumination. Direct sunlight or light from reflector lamps is very hard and contrasty and should be avoided. To reduce the lighting contrast, move the object into the shade or cover the reflector lamps with diffusing screens. Remeasure the light and dark areas; if the difference between these areas still exceeds two f-stops, contrast must be reduced through film selection and development.

Reducing Film Contrast

The ultra-fine-grain, slow films frequently used in object photography (Panatomic-X, Ilford Pan F, Agfa Professional 25) show a relatively high contrast that will increase the contrast already present in an object. One way to reduce this contrast is to select a medium-speed film that still has very fine grain but offers a wider range of contrast (Plus-X, Ilford FP 4, Agfa Professional 100). When such a film is used in combination with the reduced development time described below, almost any contrast problem can be solved, and a high degree of detail will be recorded in both the dark and light areas of an object.

9-24. The same detail, photographed with the same film but exposed for ASA 25 instead of the standard speed of ASA 125; subsequent development time was reduced by 50 percent. (Artist: Bonny Schmid-Burleson, U.S.A.)

Reducing Film Development

Modifying the developing time after the film has been exposed is the most efficient and successful way to alter the contrast range of a black-and-white film. Reduced developing time will reduce contrast, whereas increased time will increase contrast. This principle may be applied to all black-and-white films.

It is very important to remember that development time can be shortened only if the film has been overexposed to a certain degree during the picture taking. A simple approach to overexposing film enough to allow for reduced development is to set your film speed to one-fourth the speed indicated on the film. For instance, instead of ASA 125 for Plus-X film, set the speed for ASA 25. If you do not develop the film yourself, remember to inform the processor of the new film speed so that the intentional overexposure can be compensated for with reduced development time. For home developing, the developing time should be 50 to 60 percent of the standard time.

Reduced development also has a positive effect on the film grain, since reduced development reduces grain, just as increased development increases it.

Reducing Printing Contrast

The last step in reducing contrast takes place in the darkroom and often becomes necessary if the previous methods have not been applied or have been applied incorrectly. A high-contrast negative can be printed on a low-contrast, "soft" enlarging paper, which in turn can be developed in "soft", low-contrast developer. Since a loss in brilliance and tonal gradation results from this process, it should be applied only in an emergency to improve a print otherwise unsatisfactory.

10

Care of Film and Prints

An excellent photograph is the result of a high level of skill and care throughout the entire picture-taking process, including the final steps after a roll of film has been exposed. Many hours of painstaking work have been ruined by depositing film in overheated cars parked in the sun on a hot summer day; precious negatives or slides have been scratched by antistatic cloths or soiled by fingerprints due to careless handling. A photographic image remains highly vulnerable, especially after the decisive "click."

UNDEVELOPED FILM

The unloading of exposed film, just like the loading of fresh film, should take place in the shade or in subdued light to prevent excess light from entering the film protection. For the same reason, the film end should not be entirely rewound into the cartridge after exposure.

Color film is entremely heat-sensitive and should be stored in a cool place in its container, preferably in a refrigerator, before and after exposure. Unexposed film must be allowed to warm up to room temperature for about 15 minutes before opening the sealed film container and loading it into the camera; otherwise, condensation of air humidity will occur. When you work outdoors in summer, wrap film in aluminum foil to reflect external heat. Always have exposed film processed as soon as possible.

DEVELOPED FILM

Developed black-and-white or color film is very fragile and must be treated with the utmost care. Dust and fingerprints are its greatest enemies. Therefore, a negative strip should always be handled with extreme caution when removed from the holder. Extremely fine scratches on film show up on the print as thin, white streaks that are nearly impossible to retouch. These scratches, which may run from one end of a strip to the other, often result from trying to remove fingerprints or dry marks with an antistatic cloth. Negatives must be stored separately in film-strip holders and never in a roll, loosely in an envelope, or in several layers in a holder. Some finishers still deliver developed film that is simply rolled up and fitted into a container; negatives are easily scratched by such careless handling. Indicate to your finisher that film not sufficiently protected by a film-strip holder, a film pocket, or a protecting foil is unacceptable.

Color slide film is either returned framed, which is adequate for dust-free storing, or in clear acetate holders, which also provide sufficient protection. However, if you order your slides unframed, be sure to indicate that they should not be rolled, as some finishers even roll slide film!

Judging negative images on a roll of black-and-white film is a matter of experience and is particularly difficult with a series of almost identical subjects or bracketed exposures on the small 35-mm frames. Contact prints should be ordered with development, as these provide an unenlarged positive image that can be screened with a magnifying glass. Magnifying glasses equipped with a small lamp are ideally suited for this purpose.

PRINTS

The ideal print size for publishers, printers, jurors, or customers is the 8-inch by 10-inch format. Publishers and printers prefer glossy, unmounted prints with a ½-inch white border for layout notations. For your personal portfolio, a borderless print mounted on a matching cardboard (generally gray or black) or other suitable and interesting background material is more impressive.

The standard glossy black-and-white print may be altered with the mat or semimat enlarging papers offered by many finishers. A slight brown tint on a black-and-white print adds warmth and gives an interesting tonal quality to the print.

Whereas color slide film is processed under such standardized conditions that loss in quality is highly improbable, automatic print processing is a very different matter. In most cases, expert individual treatment is necessary to bring out the full potential of a negative. This type of individual handling is provided by customs labs, which offer negative development and enlargement as well as correction of perspective and distortion. If requested, they can also handle *printing in* (also called *burning in*) areas that are too light and *dodging in* areas that are too dark. Customs labs also offer dry mounting and toning of enlarged prints. Addresses of customs labs may be found in the classified sections of photography magazines.

Spotting

If the print is not already spotted by the finisher — and it may not be — do take the time to cover (*spot*) any tiny, white dust marks, which are disturbing in an enlargement. Use a fine (number 0) brush and retouching colors, which are available in photo-supply stores. For gray tones in black-and-white prints, the matching tone is mixed from black and white with a trace of water and then transferred on the pointed tip of the brush. As this requires a little experience as well as patience, you should first try spotting a relatively unimportant print. To spot dust marks on color prints, use either a watercolor set and mix the proper shades or a color retouching kit, which is also available in photo-supply stores.

PREPARING PRINTS FOR PUBLICATION

Prints intended for publication should be accompanied by a caption that includes:

name of artist
title and size of piece
description of materials and processes
name of photographer

Captions should be typed on separate pieces of paper and then taped to the back of the print. To prevent loss or misplacement of prints, you should also stamp your address on the back of the print. Do not write with a ball-point pen or any other writing implement that may leave pressure marks on the print. For the same reason, paper clips should not be used to attach information to the print.

If the print does not show the final cropping, indicate the desired cropping with an overlay of tracing paper rather than cutting the print down or marking on the surface of the print. Likewise, do not mark directly on slides.

When black-and-white prints are requested, send prints and not 35-mm slides. Prints made from slides suffer a great loss in quality. For color reproductions, color transparencies should be sent rather than prints. The larger the transparency, the better the quality of reproduction.

Let me conclude by saying that the way to achieve better object photographs is by a thorough understanding of the important photographic variables controlling the quality of a photograph — depth of field, contrast, illumination, and background, to name just a few. The information and illustrations in this book should give you this understanding. It should be supplemented, however, by a constant analysis of the many excellent examples of object photographs to be found in leading art or craft magazines, catalogs, and books. Both theory and inspiration, combined with the willingness to search for new creative approaches, will help you become a superior photographer of your work.